IMAGES
of America

LINCOLN

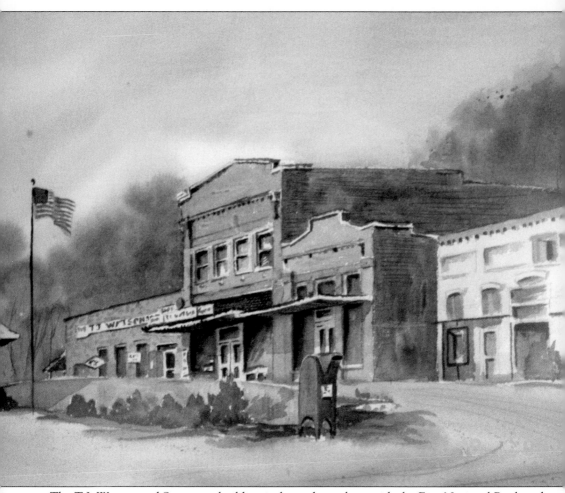

The T.J. Watson and Sons store building is shown here along with the First National Bank and the Rex Theatre. (Courtesy of Bob Watson.)

IMAGES
of America

LINCOLN

Kelly Love

ARCADIA

Published by Arcadia Publishing
Charleston SC, Chicago IL, Portsmouth NH, San Francisco CA

Printed in Great Britain

Library of Congress Catalog Card Number: 2004109720

For all general information contact Arcadia Publishing at:
Telephone 843-853-2070
Fax 843-853-0044
E-mail sales@arcadiapublishing.com
For customer service and orders:
Toll-Free 1-888-313-2665

Visit us on the internet at http://www.arcadiapublishing.com

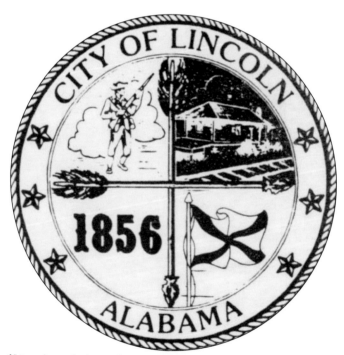

The first City of Lincoln seal, shown here, was designed to reflect the city's pioneer heritage, its connection to the railroad, and the year the name was changed from Kingsville to Lincoln. Note the arrows in the design, which reflect the city's Native American heritage.

CONTENTS

ACKNOWLEDGMENTS

The compilation of this book of photographs has been truly a community project. Many local people have helped with it; my thanks go to them for their assistance with different aspects of the book and to each and every person who loaned me personal photographs.

Particularly, I thank Laura Cheloke, Bob and Sara Watson, Barbara Goldstein Bonfield, Jimmy Goldstein, the Burns family, the Colvin family, Frances Bowman, Mildred Trammell, Lew Watson, the City of Lincoln, Charles Disspain, Margaret Mongold, and other members of the Historic Lincoln Preservation Foundation Book Committee. The written records of John David McClurkin and the late Earline Sanders and Mary Henderson were invaluable. It was their vision and love for the people of Lincoln that brought this historic record to reality.

Also, I thank my family. My parents, my husband, and my children were supportive throughout and gave me the freedom to create this book. There wasn't a time I called a member of my extended family to ask a question about this person or that street or house that I didn't receive an answer. To them, I express my deepest appreciation.

Lastly, I dedicate this book and the words written within to the memories of my grandparents, Dave and Audrey Disspain, Finnell and Inez Trammell, my aunt Barbara Disspain, and my entire family. From them I learned the truth in these words: families are one of God's greatest treasures.

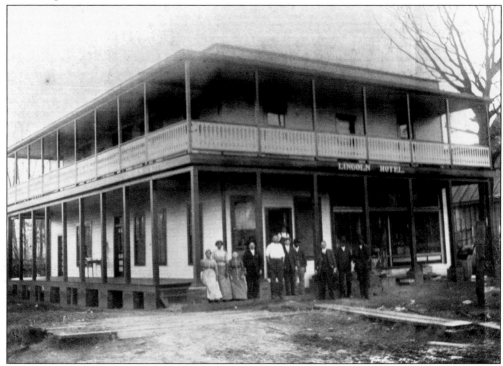

The Lincoln Hotel was located adjacent to the railroad tracks in downtown. The people in the photograph are unidentified.

INTRODUCTION

Welcome to the first pictorial and written history of Lincoln and surrounding communities. This book seeks to record a portion of the history of Lincoln from the 1880s, when the railroad tracks were laid and the old downtown near Magnolia Street was built, to the 1960s, when Interstate 20 arrived and Logan Martin Dam was built.

In the early 19th century, pioneers came to the northern part of Alabama from Virginia, the Carolinas, and Georgia. In 1813, Andrew Jackson came to Fort Strother, north of Lincoln, with troops numbering more than 2,500 men. This opened up the area to early settlers. The soldiers who accompanied him saw beautiful land, lush forests, wildlife, and navigable waterways. Creek, Cherokee, Red Stick, and Muskogee Indians occupied Alabama at that time, and their legends are associated with familiar names in today's local language: Choccolocco, Coosa, Cheaha, Conchardee, and Blue Eye. Choccolocco and Conchardee (Econchardee) were Native American villages along the Choccolocco Creek. One enduring legend says that Blue Eye Creek, which flows through town, was named for a Native American with one blue and one black eye, and that if you ever wet your feet in that creek, you'll come back to visit Lincoln.

After the Cussetta Treaty in 1832, Jackson's soldiers and others made their way back to Alabama and sought land grants. By the 1830s, it was considered safe enough for them to bring their families to homestead. Over the next two decades, pioneer families came by horseback, wagon, and even on foot and settled in Dry Valley, Eureka, Embry's Bend, Rushing Springs, and a place called Kingsville. In the latter, which is shown by early records to have been located near the Jessee Hardin House, a post office was established on January 17, 1856. At this time, the name of the town was changed to Lincoln, in honor of the beloved Gen. Benjamin Lincoln, defender of Charleston, South Carolina, during the Revolutionary War.

Construction of the Georgia Pacific Railroad from Birmingham to Atlanta in the 1880s further opened the town of Lincoln to development. The posters made for the sale, dated September 26, 1883, tout an excellent opportunity for investment: "Society is good," one poster said, "the people being intelligent and well-to-do."

Early schools were small with one or two rooms in church buildings at Blue Eye Church, Refuge, Patton's Chapel, Eureka, Rabbitt Branch, and Conchardee. Just before 1900, a three-room, wooden schoolhouse was built near Lincoln Cemetery and used until 1925. Talladega County High School was built in Lincoln, and this, too, was a milestone in the city's development. Construction began on the new school in 1911, and the event more than likely prompted the city's incorporation the same year. Also, a mayor, W.D. Henderson, was elected, as were the first councilmen.

More advancements were made when the first telephones were installed in 1909. Electric power came in about 1915, and a water system was made available to the people in 1933 and 1934. The first streets were paved in 1940.

At the time of the Great Depression, however, Lincoln suffered just like the rest of the country. Banks failed, several stores closed, and the people of Lincoln made many sacrifices. During these years, there was very little progress in town development. In fact, more than 50 years after its incorporation, the city limits were still as they were in 1911: one square mile. A turning point came in 1967, when a civic action committee was formed, and a booklet entitled "A Green Light for Tomorrow" was developed. The latter listed the possibilities Lincoln had for growth. The committee was expanded, and work began on plans for the booklet's objectives. The progress initiated by this committee still continues to this day.

As Lincoln prepares for the 150th anniversary of its official naming (January 17, 2006) and the 100th anniversary of its incorporation (2011), the new industries and business opportunities will irrevocably change the town's landscape and people. But, as they have for decades, the common, everyday names of Lincoln will remind us of those who came before and will cause us to pause, reflect, and remember.

STATE OF ALABAMA
TALLADEGA COUNTY

We, the undersigned enumerators appointed by the Probate Judge of Talladega County, Alabama, to take the census or enumeration of the inhabitants in the community above described to be embraced within the proposed town of Lincoln, do hereby certify that we have enumerated the inhabitants residing within such territory, and having completed the same do hereby return the same to the Probate Court, and certify that the foregoing is a correct enumeration of said inhabitants and that the number of inhabitants residing in such community is _408_ all of which we accordingly do within three days after the completion of such enumeration.

This the _31_ day of January, 1911

W.D. Henderson
W.A. Kirksey
W.D. Davis
Enumerators

IN RE IN THE PROBATE COURT OF INCORPORATION OF LINCOLN, PROPOSED MUNICIPAL INCORPORATION TALLADEGA COUNTY

Enumeration of the inhabitants residing within the proposed town of Lincoln, which is described as follows:

The whole of Section 28 and the S 3/4 of the S 1/2 of the S 1/2 of Section 21, Township 16 South, Range 5 East, Talladega County, Alabama,

said territory being shown by a plat on file in the office of the Probate Judge of Talladega County, Alabama, as also being described in the petition for the incorporation thereof.

NAME (AGE)

ACKER, E D (49), Lula (49), May Belle (23), Joe R (22), Ruth (16), Elizabeth (7); BROWN B F (54), Lizzie (45), Claud (14); EMBRY Lon (41), Julia F (38), Zac (16), Claire (2); WILSON Warren (35), Josie (28), Maudie (8), Bertha (5), Luther (2);

GOVER Clause (28), Bulah (27), Prymer (7), Ceola (4), Boysie (2); JACKSON Mollie (49), Hager (18), Ham (15), Beatrice (14); SWAFFORD J B (68), Agnes (66), R D (34), Partheny (20), George (36), Josie (36), Lillie May (8), James (5), Millie (3), Louise (6 mo); DOBBINS Walter (49), Wallace (18), John (27), Ada (23), Lonnie (7), Ollis (4), Velma (3), Stella (1);

ELSTON Peggy (70); SIMS Georgian (41), Rasa (21); KIRKSEY Lee (29), Cora (16); CURRY Walker (33), Lela (24), John (5), Ella (4), Theola (2), Arthur (80), Annie (25); DOZIER Pearl (29), Wallis (9), Carrie (7), Telie (4), Willie (2); DOBBINS Ary (52), Peyton (21), Harriett (16); MOSS Mary (12); GOVER Homer (26), Mattie (20), Percy (2), Ray (20), Mamie (19); CURRY Ed (36), Laura (38), Eddie May (11), Lonnie (9), Odell (7), Mattie (2), Walter (4 mo); EMBRY Callie (32), Hannah (34); BRITTAIN Hannah (52); WEED S T (79); KIRKSEY W A (41), Agnes (34), Ethel (9), Paul (8), James (7), Thomas (5), Grace (5 mo); CRAWFORD H T (22); POE A D (38), Dessie (31), Forest (11), Exer (9), Willie (6), Emeris (3); CROW Henry H (46), Viola (41), Luther (21), Frank (18), Lula (16), Robert (13), Dewey (10), Otis (8), Bulah (7), Wallace (5), Clarence (1); CRAWFORD M J (33), Blanch (27); SIMS General (23), Bessie (19), Sam (4), Lillie May (1);

HACKNEY Jno W (37), Susie (31), Eula D (10), Vera (8), Emmie (4); BRYANT Martha (61); POE E R (30), Maud (24), Inzie Bell (8), Spurgeon (5), Charles C (2); COMPTEN E B (38), Froney (30), Linda (11), Dixie (8), Addie (7 mo); SHADDIX R W (27), Fannie (26), Graham (5), Fannie (4), Annie (2); BRAMLETT W L (39), Daisy (31), George (9), Lillie Kate (7), Mary (4); RAGLAND Harvey (25), Marietta (23), Grady (2), Annie (6 mo); CAMPBELL James (36), Maggie (28), Logan (9), Erwietta (7), Lee L (4), Marzie (3); THORNTON Ned (59), Martha (47), J C (12), Lera (6), James L (18), Martha (18), John H (28), Eldora (25), Ina May (6), J H (3); EMBRY Tom (42), Maggie (41);

ALEXANDOR Paralee (71); CRAIG J C (52), C A (34); GARRETT Odessa (16), Otie (11), Nonnie (8); CARPENTER T A (44), Mattie (48), Lucile (20), Armstead (17), Geneve (14), Lillie May (12); DAVIS Walter D (35), Birdie (32), Dean (10), Francis (2); BEST Ben C (34), Lula (34), Martha (8); HENDERSON W D (42), Nevada (37), Fred (13), Ethel (10), Evelyn (3); COLVIN James P (47), Addie (40), Henry (18), Gus (11), John (8), Patti (5), Mary (2); STEVENS Miles (52), Bettie (54), Jessie (8); ORR Bedford (43), Thelie (34), Floyd (15); MONTGOMERY Henry (40), Lucy (35), Harriett (12), Jessie (9), Ether (11); DOBBINS Ella (60); WILSON J H (38), Linda L (35), J Harwell Jr (3);

HACKNEY A H (45), Nannie (41), Charles (21), Ida (19); CRAWFORD A H (67), Cordelia (56); COX John (22), Birdie (19); SULIVAN Joe M (42), Josie (41), Lillie (17), Ruth (14), Archie (11), Victor (9), Neal (2), Earnest (1), Robbie (4); SADDOX James A (53), Belle (50); MADDEN Calvin (27); HOLLINGSWORTH John C (65), M A (63); TROTTER Thomas K (59), Kate (57), Pet (31), Lucile (25), Wallis (21); THOMAS James F (54), Emma (51); RICHEY James L (43), William A (38), Mamie (23); GRIFFIN A H (66), Ella (58), Thomas F (22), Will R (34), M S (28), Irene (2); FLOYD A T (58), Malissa (58); LOVE Geo H (29), Kate (26), Charles (4); BREWER Margarette (64);

MOORE Mrs Mattie (40); DEASON B F (30), Mattie (32), Walter (10), Alfred (3), Mary (5 mo), Nolie (34), Bessie (18), Nellie (9), C B (1); BROWNING Reid (30), Maggie (23), Eddie (3); MITCHEL Amanda (45); HURST Bryce (20); DICKINSON Leon U (26), Myrtle (23), Joycelin (2); CUNINGHAM M C (37), Elzie (33), Myrtle (14), T C (7), George (6), John M (33), Minnie (24), Clarence (10), Dorris (8), Evelyn (1); PERRY M M (55), Lula (35), Leila (22), Sam B (32), Annie (30), Sam A (5), Louise (2); CARPENTER Mrs Mariah (30); BURTON S A (50), Martha (55); WILSON William C (30), Marie (25), George N (28); MORRIS Demps (43), Sallie (33);

JONES Geo W (76), Walter N (36), Wallis (34), Catherine (7), Helen (5), Loise (3), Charles (1); SAWYERS Geo W (56), Sudie C (45), J C (17), Geo D (15), Anna (13), Wallace (8); MONTGOMERY Earle (19), W A (17), Walter B (11), James M (8), Louise (5), William W (5 mo); JEMISON George (48); BURNS Robt B (47), Angie (35), Emmie T (11), Robt (9),

9

Harry (5); INZER J A (25); DENSON Mariah (55); HOLLINGSWORTH W L (30), Bessie (25); WORTHINGTON H C (65); BUSH Mary E (82), James V (40); GARRETTE Mollie (36); SIMS Josie (44), Robt (21), Essie (17), Arther (16), Jennie (12), Ola (10), George (6), Babe (3); RAGLAND Dennis (51), Ella (), Susan (22), Mary (18), Fred (14), French (7), Ella (2); DAVIS Joe (56), Amanda (45); BRITT Buster (30), Mary (28), Robt (8), Sadie (5), Fannie (3), Major (1); DISPAIN Thomas (47), Elizabeth (37), James L (18), May (16), Pearl (14), Ruby (11), Dave (7), Helen (4);

BROOKS A O (50), Fannie B (42), Thomas (18), T R (15), Euclid (9), Elizabeth (9), Mary (6), George (5); VERRELL W M (40), Janie (32), Broxie (8), Exer (5), Omie (3); BREWER Thomas (45), Viola (32), Hardin (12), O Z (9), Hardwell (7), Mary (4); GOVER Wash (54), Martha (48), Lotie (17), Law (14), Neita (12), Luster (10); NEELY Emma (34), Alice (7), Rose (5), Willie (2);

CASTLEBERRY W T (62), W A (21); ENGLAND Lester (25); YONGUE W S (29), Addie (33), William B (1); MYNATT Margarett (24), Sallie (18); GLADDEN J J (29), Georgia (27), G C (23); PHILLIPS Benton (24); CASTLEBERRY Eloise (18); CRAWFORD John W (54), Orrie (35), Mary (10), Elinor (8), John L (4); PEARSON Aaron (74); KIRKSEY Flavius (17); CUNINGHAM Mattie (25).

One

HOMES AND
HISTORIC STRUCTURES

"Remove not the ancient landmarks, which thy fathers have set."
—Proverbs 22:28

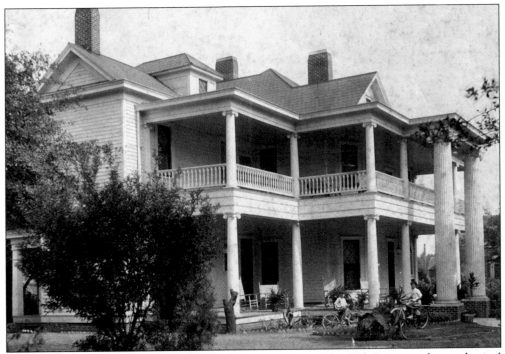

Built in 1889 by Alabama senator Robert Benjamin Burns, "the Oaks" is a stately neoclassical revival–style home featuring towering columns, sweeping porches, and oak trees over 100 years old. Occupied continuously by descendents of Robert and his wife Angie Lee Goff Barry Burns, it is home to Maudie Mae Phillips Burns today. It was added to the Alabama Register of Historic Places in 1978. This c. 1915 photo shows two of the Burns children, Harry and Robert, on bicycles in the front yard, which faces Magnolia Street. (Courtesy of the Burns family.)

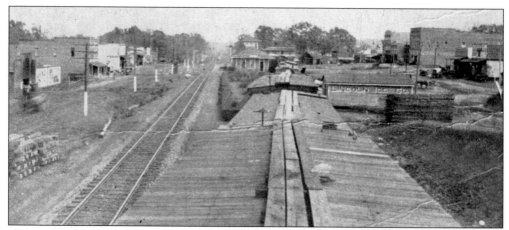

This bird's-eye view of Lincoln was apparently taken from the top of an incoming train. Watson's Store is on the right, the Lincoln Depot is straight ahead, and the Lincoln Drug Store is on the left side of the tracks. Notice the Lincoln Ice Company on the right and the wood stacked on the left side. (Courtesy of Raymond Lane.)

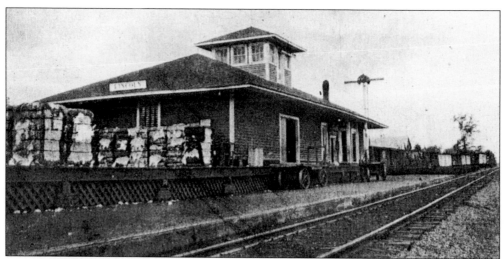

This undated photograph of the Lincoln Train Depot shows the platform loaded with bales of cotton awaiting shipment. The depot was constructed c. 1883 when the tracks and rails were laid between Birmingham and Atlanta. The first Georgia Pacific Railroad train came through Lincoln on Wednesday, September 16, 1883. The depot's facade remained the same for nearly 100 years, except for the east side of the platform when it was enlarged to hold more cotton. The Lincoln Depot was moved to the north side of the railroad tracks in 1974, where it now serves as a senior citizen center. (Courtesy of Helen Parks.)

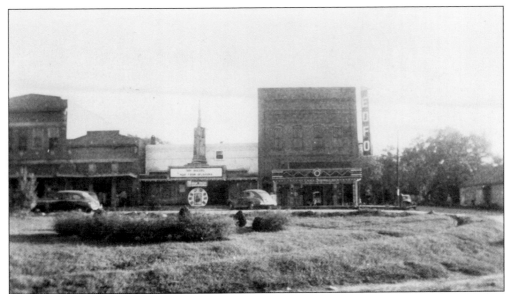

Two movie theatres, the EDFO and the Rex, were popular spots for Lincoln teenagers during the 1930s and 1940s. This photo, c. 1948, shows both buildings. The EDFO has since been destroyed. The Rex theatre was owned by Carrol Watson Sr., and his wife Ruth. Notice the 1940s-style cars. Magnolia Street runs to the right of the EDFO. (Courtesy of Bob Watson.)

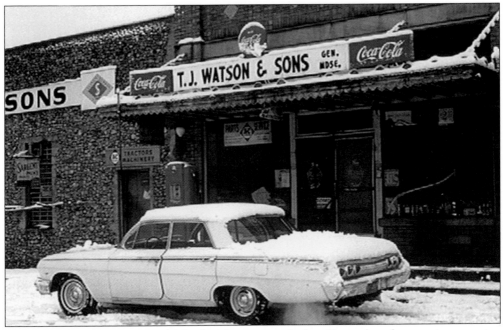

T.J. Watson and Sons General Merchandise store, which still stands today, was in operation from 1932 to 1986. This photo, c. 1963, was taken during a rare snowfall that exceeded four inches. Note the Allis Chalmers and Coca-Cola signs and the wooden-screen front entrance doors. (Courtesy of Bob Watson.)

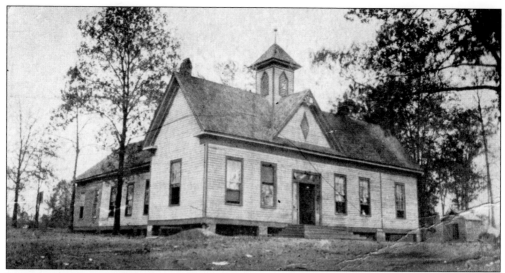

This three-room, wooden frame building was built a decade before the end of the 19th century and stood in a pine grove near Lincoln Cemetery. It is believed to have been the first public school in the town. Courses were offered in Latin and Greek, and nearly every child in Lincoln received instruction from teachers Miss Pet Trotter, Miss Taribay, Miss Ledbetter, and Mr. Reaves. A receipt dated October 25, 1908, states that Mr. J.W. Crawford paid $2 tuition for his daughters Mary and Eleanor. The building was used until 1925. (Courtesy of HLPF Archives.)

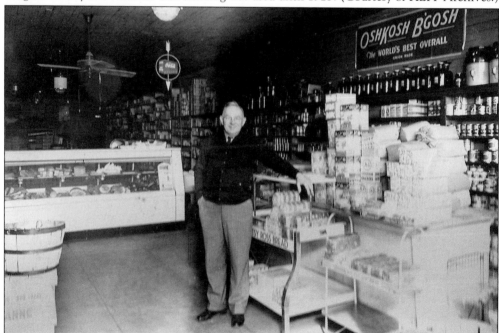

Hal Dickinson is shown here in his general mercantile store c. 1930. The store was located near the railroad tracks on the east side. The building burned in the 1960s. Hal was a dedicated fox hunter. His family recalls that after one particularly long Saturday night hunt with the Colvins, Hal became tired in church and began to wind his watch. The minister never missed a beat and said, "Hal, I'll be finished in a minute, but put your watch away." (Courtesy of Rozelle family.)

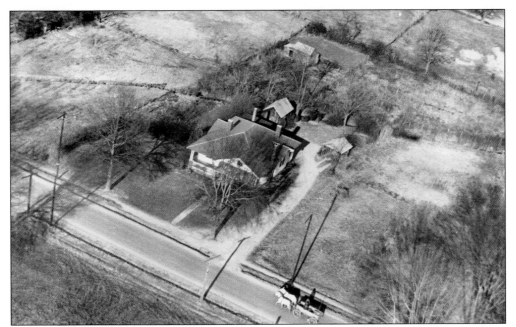

This *c.* 1948 aerial view of Magnolia Street shows what was then known as the Lester England House, built *c.* 1925, which later became home to Thomas Robert and Willie Dee (Green) Watson. The house's address today is 320 Magnolia Street. Even as late as the 1940s, teams of horses and wagons could be seen en route to a thriving downtown Lincoln business district. Today, homes stand on what were then vacant areas on either side and in back of this house. (Courtesy of Bob Watson.)

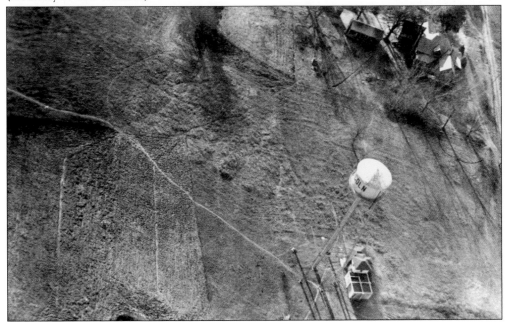

This *c.* 1948 aerial view of the Lincoln Water Tower, located just off Magnolia Street near the downtown area, shows rural, open fields with sparse housing. The Sullivan home is at the top right of the image. (Courtesy of Bob Watson.)

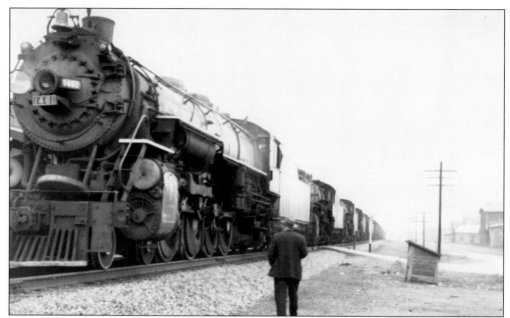

Southern Railroad made Lincoln a major stop along its Atlanta-to-Birmingham line c. 1883, not long after the tracks were laid. To accommodate the travelers and residents, a depot was built, and businesses sprang up on both sides of the street. The train pictured here c. 1945 with the Lincoln Depot in the background was the #1461 engine. (Courtesy of HLPF archives.)

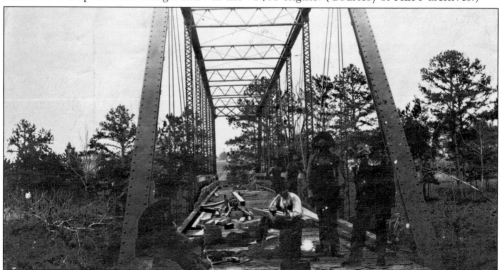

In 1906, this high steel-truss bridge was built across Choccolocco Creek at Conchardee, just downstream from the Schmidt Mills and the old flat bridge. Prior to 1835, no bridges crossed any stream in Talladega County, although 16 creeks could not be forded at that time. In August 1844, $50 was set aside to build a bridge on McIntosh Road to cross Choccolocco Creek. It is believed that this refers to the original flat bridge at Conchardee. These low bridges frequently flooded and, when two washed out and a third was almost destroyed in the floods of 1886, it was finally recommended that this style bridge no longer be built. Thus, steel-truss bridges came into being. This one was replaced in 1937 with the first of the two present-day bridges on Alabama Highway 77. (Courtesy of Laura Cheloke.)

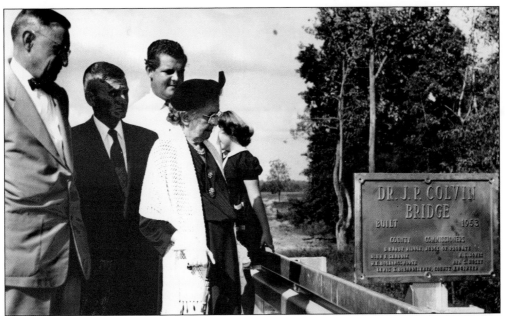

Assembled on the Dr. J.P. Colvin Bridge *c*. 1953 for a dedication ceremony are (left to right) Dr. Gus Colvin, Talladega County commissioner John F. Shaddix, then Lincoln mayor William (Bill) Sullivan, and Colvin's mother, Mrs. J.P. Colvin. The newly formed Lincoln band played for the occasion. The new bridge spanned Blue Eye Creek and is heavily used today, more than 50 years later, as the main connection between Lincoln and the new Lincoln School complex. At the time, the bridge was a great relief to residents because the creek would overrun its banks, particularly during 1948. However, despite the floods, the waterway was also a great asset. On April 21, 1952, a *Talladega Daily Home* article stated, "Blue Eye Creek saved the town when a night fire destroyed two general stores (owned by Millard Hearn and James Johnson) and a barn containing 15 tons of hay (owned by Lester England)." (Courtesy of HLPF archives.)

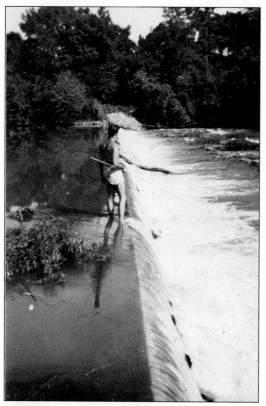

James L. Colvin, son of Alma and Henry Colvin, fishes off the dam at Schmidt's Mill, a popular fishing and swimming spot for many years. Men used to camp out on the creek for several weeks at a time when the "red horse" were abundant. According to Ollis Madden, the "red horse," also called "suckers," were a species of fish all their own. They migrated up the creek every year from April to early May to spawn and stayed for a couple of weeks. The typical red horse caught in this region weighed anywhere from 3 to 15 pounds, though larger ones were caught occasionally. Their name comes from their coloring; they had a reddish tinge with a dark head and a blood red tail during spawning. These fish disappeared when the Coosa was dammed and the creek was backed up. On the shore, G.L. Schmidt cooked pots of hominy every year, and baptisms were held below the mill. It is still a popular fishing spot, but gone is G.L.'s box by the gate where visitors deposited 10¢ to fish any day of the week except Sunday. (Courtesy of James L. Colvin.)

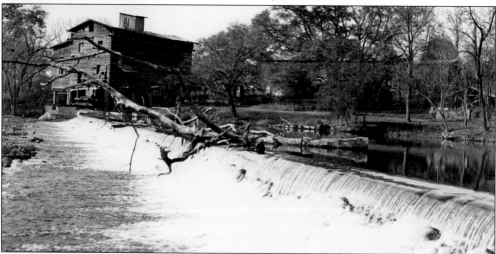

Pictured are the grist mill, cotton gin, oil mill, and blacksmith's shop at Schmidt's Mill. The original grist mill was built by Jacob Harmon and Bernhard Schmidt in 1865. In 1873, Bernhard purchased Jacob's share and added a cotton gin and later an oil mill. In the floods of 1886, the grist mill and cotton gin were destroyed. The mill shown here, c. 1940, was built by Bernhard's son G.L. Schmidt. G.L. operated the mill until around 1937, at which point his son Bernard took over. G.L. and Bernard became full partners in 1945. Bernard continued operations until the early 1960s, when the river was dammed and the mill destroyed. He continued to grind meal and flour with a small grinder until his death in 1988. (Courtesy of Laura Cheloke.)

18

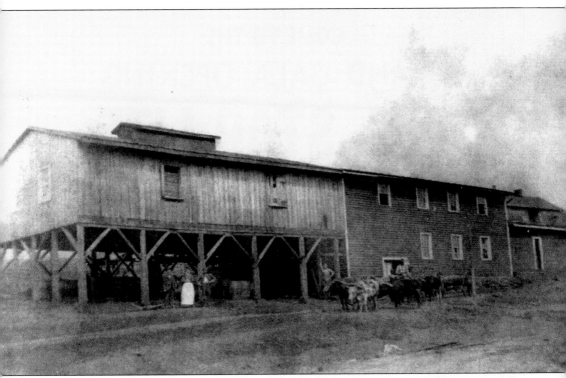

The Schmidt oil mill at Conchardee operated from 1883 to 1913. It processed cotton seeds by cleaning, removing the linters, separating the oil-bearing kernels from the hulls, flaking and cooking the kernels to facilitate oil recovery, and extracting the oil from the kernels. The resulting products became known as cotton seed cakes. Large barrels of oil were loaded on a wagon pulled by oxen and driven by Willie Mitchell to Talladega for additional processing. If Willie arrived before Bernhard Schmidt, who arrived by horse and buggy, Willie would buy a beer for a nickel at the saloon and wait for him to catch up. (Courtesy of Laura Cheloke.)

During the summer of 1950, a new form of entertainment came to Lincoln at the Star-Lite Drive-In Theatre. Ronald Reagan (later President Reagan) and Patricia Neal starred in *The Hasty Heart*, the first feature film to be shown. The theatre was owned by Ruth and Carroll Watson, who charged an admission of 39¢ per person. It was in operation for seven years and stood where Lincoln Shopping Center (Super Foods) stands today. (Courtesy of Lew Watson.)

20

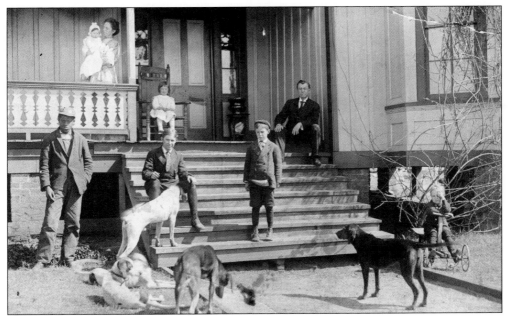

The Colvins were photographed *c.* 1909 with some of their famous foxhounds. Colvin men were avid fox hunters. Notice Gus Colvin, standing on the steps, with his fox hunting horn around his neck. His daughter, Patty Colvin Hall, recalls him hunting in Embry's Bend on Ragland Mountain (the hill near the entrance to Speedway Boulevard on Alabama Highway 77), and off Woods Ferry Road. The horn was used to call the dogs in, usually the day after a hunt. Pictured (left to right) are Miles Stephens, Mary Colvin Hoffman (baby), Addie McRae Colvin, Pattie Colvin Thigpen (sitting in rocker), Charles Henry Colvin, Gus Wilson Colvin, Dr. James Pickett Colvin, and John McRae Colvin (in yard.) (Courtesy of Colvin family.)

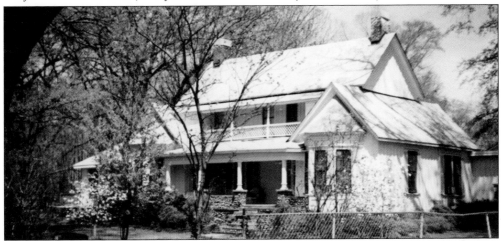

The Lanier-Colvin house, located across the street from the Lincoln Baptist Church at 119 First Avenue, was built by Mr. Lanier, who owned a sawmill in Lincoln. The home was constructed with some of his best lumber. Dr. J.P. Colvin bought the house in 1905, and his children, Henry, Gus, Pattie, John, and Mary, grew up there. Later, Dr. Gus Colvin's children were born there. Gus built a medical office on the grounds behind the house, where he saw patients for many years. Mrs. J.P. Colvin lived in the house for 54 years. In the 1960s, Mrs. Pattie Colvin Thigpen had the house restored, repaired, and modernized. (Courtesy of HLPF archives.)

21

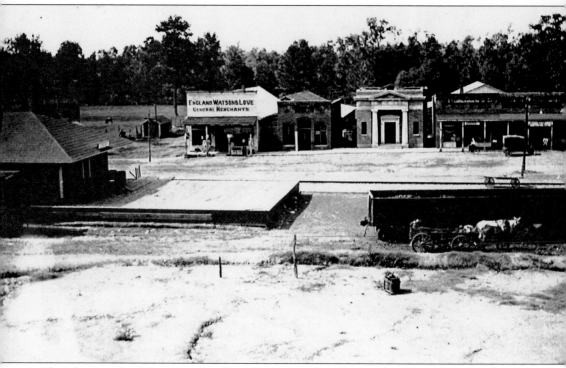

This photograph of the east side of Lincoln's railroad tracks is undated but was certainly taken before 1930. Note the enlarged platform on the Lincoln Depot and the oxen hitched to the wagon near the rail car. (Courtesy of HLPF archives.)

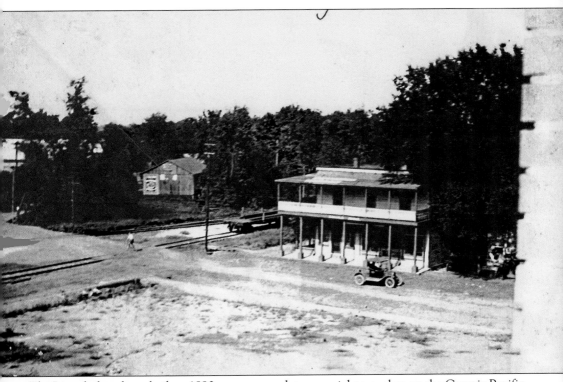

The Lincoln hotel was built c. 1890 to accommodate overnight travelers on the Georgia Pacific Railroad. There are no records to speak of, though local historians can recall a restaurant where locals and travelers could dine. The hotel burned c. 1929 and was not replaced. (Courtesy of Bob Watson.)

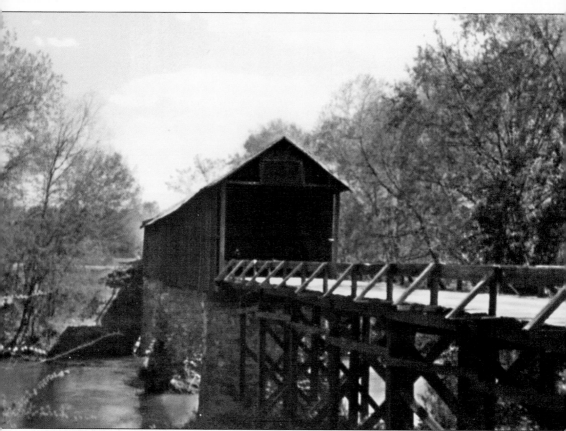

Built in 1903, Eureka Wooden Covered Bridge that once spanned Choccolocco Creek stood for more than 60 years and was once known as the "kissing bridge." The piers were huge stone and concrete pillars, protruding nearly 20 feet above the water, were built strong enough to support cars, though there were none in the area at that time. In a *Birmingham News* article, Mrs. Linda (Compton) Dunston recalls, "I couldn't wait for them to finish the bridge because I wanted to be the first one across it." Linda remembers the bridge as a place to play hide-and-seek and as a shelter if she was caught in a sudden rain. She even learned the sound of the gait of her daddy's horse and knew when he was coming home. "I got to where I could tell his horse from all the others and I'd know it was him the minute he hit the bridge." On July 15, 1963, just before the newly constructed Logan Martin Dam backed up water from Choccolocco Creek and the Coosa River to form Logan Martin Lake, vandals set fire to Eureka Wooden Covered Bridge, destroying it. Though the bridge probably would have been ruined in time by rising water, Linda Dunston, who witnessed the bridge burn, recalls the day with great sadness: "I guess I was hoping there might be some way to take it down and put it up again somewhere else. They don't build bridges like that anymore." The bridge stood near today's Choccolocco Creek Bridge on Talladega County Highway 207. (Courtesy of HLPF archives.)

Two
EDUCATION

Alma Mater
Steadfast, loyal, ever true,
To thee we'll always be.
Gold and black will reign forever,
In our hearts to thee.
—from the 1945 *Lincolnian*

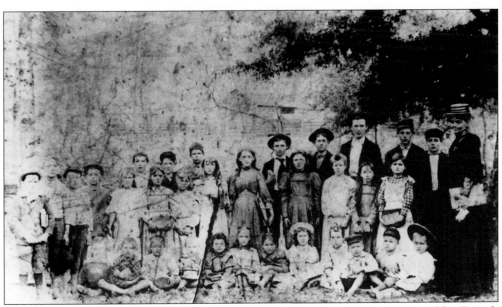

Magnolia Embry (far right wearing a hat) is shown here with her students at Rabbit Branch School, located near Embry Cross Roads. Legend says that one of the city planners was smitten with Magnolia and named the main thoroughfare Magnolia Street in her honor. Her brother Alonzo (Lon) Embry is buried at Blue Eye Cemetery. Identified students in this *c.* 1890 photograph are Margaret Caroline (Franklin) Evans (fifth from left, standing) and Jeremiah Bernard Franklin (second from the right). (Courtesy of the Goldstein family.)

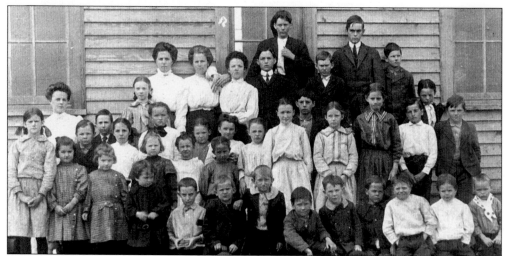

Conchardee School, shown c. 1908, was located on a bluff overlooking Choccolocco Creek. Alma Schmidt, daughter of G.L. Schmidt and Inez Cofield, seen standing just below and to the left of the three ladies, later taught at Conchardee. Her sister Dorothy is two rows in front of her. Other teachers included Mae Belle Acker, whose parents Elisa David Acker and Lula M. Ragan moved to Lincoln in 1892, and Mary Jane Hackney. Inez Schmidt taught Sunday school there. Later, Elliot and Leona Frieze remodeled it and lived there, and Lonnie Mitchell, who drove for Dr. Gus Colvin, lived there for a time. Still later, it was used to store hay, and eventually it burned. (Courtesy of Laura Cheloke.)

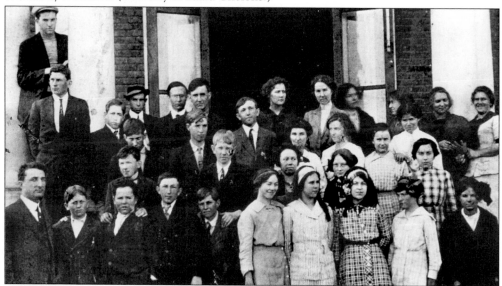

Legislation passed in Alabama in 1907 established a high school in each county. Lincoln was fortunate enough, because of the efforts of local people, to be the home of the new Talladega County High School. This photograph shows what are thought to be high school students on the front steps c. 1913. Identified students are (first row, from left to right, beginning fifth from the left) Gus Colvin, Alma Schmidt, Linda Compton, Emitom Burns, unidentified, and Jenieve Watson; (second row) Byron Watson and Frank Lane; (third row) unidentified and Flora Watson; (fourth row) Burl S. Watson. Burl was the first graduate from Talladega County High School; this picture more than likely shows his senior year. (Courtesy of Laura Cheloke.)

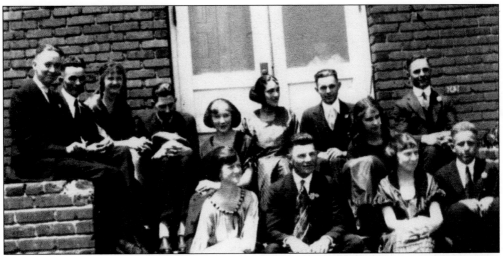

The Lincoln High School graduating class of 1922 included, from left to right, (front row) Myrtle Evelyn Golden, Sanford Eugene Suggs, Conola Shaddix, and Frank B. Wood; (back row) Bernard Schmidt, Myron Bryce Waites, Myrtice Taylor, Charles T. Love, Ethel Ruth Acker, Mary Clare Burell, George T. Morris, Eleanor Crawford, and Shelton Allred. (Courtesy of Laura Cheloke.)

THE WREN

Presented by Senior Class T. C. H. S.

High School Auditorium, May 15, 8:00 P. M.

Directed by
MISS LOYCE HENDRIX

CAST OF CHARACTERS:

Mrs. Julia Danna—A Soldier's Mother	Lorene Merkl
Robert Danna—The Soldier	George Brooks
Jane Danna—The "Wren"	Mary Elizabeth Poe
Sarah Woodston—Jane's Friend	Lula Mae Coker
Donald Drew—Another Friend	Billy Montgomery
Mammy—That's All	Pearl Champion
Mrs. Harriet Greenston—A Business Woman	Topaz Cater
Reginald Greenston—Her Spoiled Boy	Francis Davis
Mrs. Cecelia Danna Fordston—Jane's Aunt	Dollie Belle House
Corinne Fordston—Jane's Cousin	Joyce Dickinson
Binkie—Mrs. Fordston's Maid	Fannie Lou Poe
Rodney Blake, Sr.—A Foster Father	Grady Martin
Mrs. Rodney Blake—A Foster Mother	Louise Perry
Rodney Blake, Jr.—An Adopted Son	Joe Hutto
Judge Gray—A Lawyer	Clifford McClellan

ACT I—Scene I—Living Room in the home of Mrs. Danna, down on the farm.

ACT II—Scene I—Reception room in the home of Mrs. Fordston in Chicago, next morning.

ACT III—Scene I—Same as Act II, two weeks later.

Act III—Scene II—In the home of Rodney, two hours later.

ACT IV—Same as Act I, next day.

MUSIC BY MISS JOHNNILEE CRAWFORD

This is a program from the 1925 Talladega County High School senior play. (Courtesy of HLPF archives.)

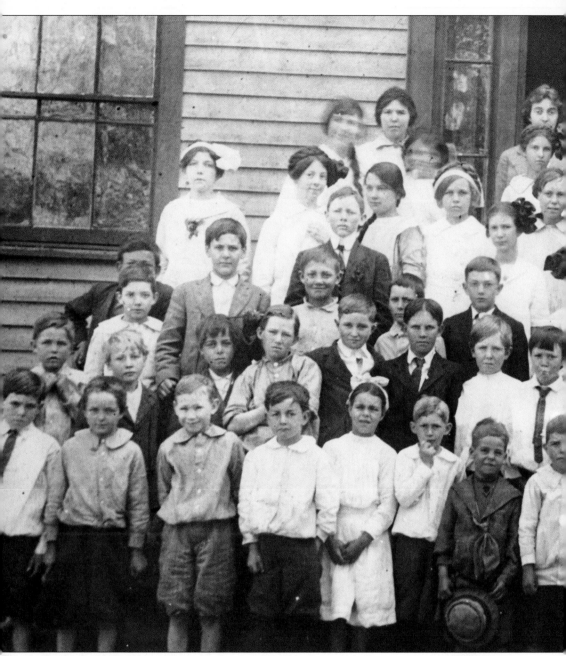

Students in Lincoln public schools *c.* 1910–1911 attended classes in a three-room structure near the present-day Lincoln Cemetery. Pictured, as identified on the back of the photograph, are from left to right (first row) Earnest Branlett, John Watson, George Brooks, Tom Kirksey, May McBurnett, Ralph Hill, Torney Bramlett, Bill Gambrell, Clara Gambrell, Earnest Sullivan, Addie Compton, Mary Waren Bramlett, Bonnie Dean Meharg, Emmie John Hackney, Pattie Colvin, and Louise Montgomery; (second row) Miles Gambrell, Luther Davidson, Allen McBurnett, Phil Martin, John Colvin, Victor Sullivan, Alva Meharg, Dave Disspain, Josey Bramlett, Martha Best, Mary Brooks, Clara Bell Lee, Louise Gambrell, Vera Suggs, Ruth Humpres, Myrtle Golden, and Elizabeth Acker; (third row) Trent Bonner, Eldred

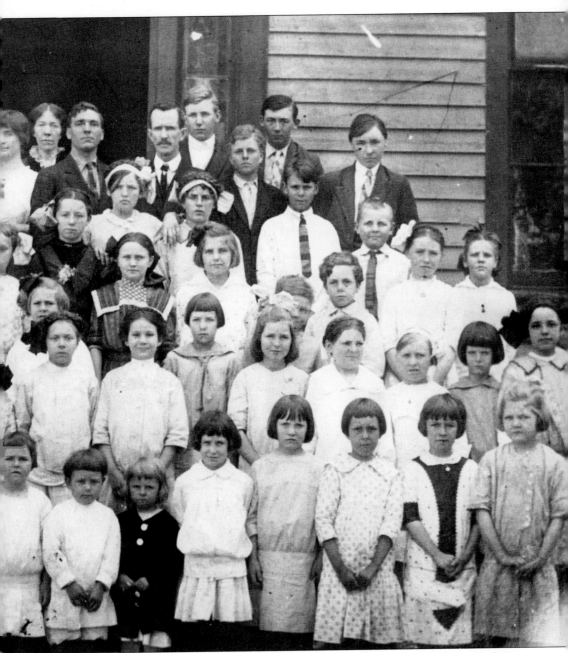

Merkl (behind Bonner), Robert Burns, Everet Payne, Neal Sullivan, Paul Kirksey, Cathrine Jones, Helen Jones, Jewell Boozer, Dixie Compton, Kennedy Watson Jr., Jim Kirksey, Eva Easterwood, and Vista Knox; (fourth row) Lillie May Carpenter, Ethel Henderson, Ethel Kirksey, Walter Green, Eula Hackney, Elizabeth Brooks, Ruby Tom Disspain, Vera Hackney, Lena Easterwood, Carry Green, Inez Davidson, Archie Sullivan, and Jim Montgomery; (fifth row) Jimmie Gambrell, Summer Gambrell, Elnor Crawford, Mary Crawford, Miss Ledbetter, Miss Tariby, Miss Pet Trotter, Henry Hines, Mr. Reaves, Luther Hollingsworth, Clarence Franklin, Bill Easterwood, and Leonard Easterwood. (Courtesy of HLPF archives.)

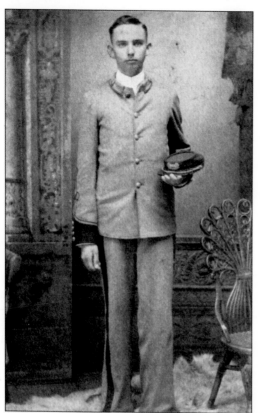

Thomas Jefferson Watson is pictured here as a Howard College (now Samford University) student. He was enrolled for the 1893–1894 school year, and he married on February 6, 1895. On the enrollment sheet, his address was listed as Riverside, Talladega County, Alabama. (Courtesy of Betty Watson Bullock.)

There are no records to indicate the identity of this girls basketball team at Talladega County High School in 1929. The photo was found in the school archives, and the team was mentioned only in a December 21, 1928, newsletter that states: "Both the boys and girls begin their basketball schedule immediately after the holidays. The boys again have a strong team, and we look to see them better the excellent record of last year." Girls in the 1929 graduating class of 13 students were Eula Allred, Ruby Coker, Sara Henderson, Thelma Hollingsworth, Louise Macon, Ruth Parker, and Ruth Poe. (Courtesy of HLPF archives.)

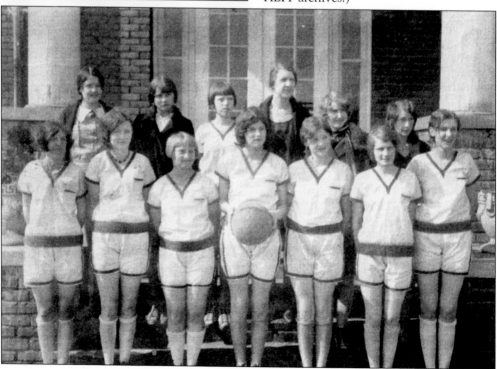

Pictured in front of Lincoln High School are, from left to right, Margaret Allred, Roy Hollingsworth, Sara Heibman, and Helen Winslette. (Courtesy of the Goldstein family.)

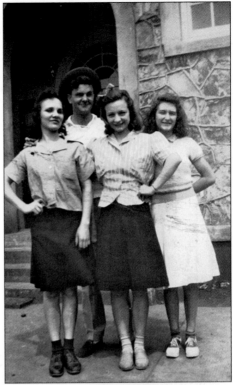

Lincoln High School Senior Class Officers from 1947 are, from left to right, the following: James L. Colvin, treasurer; Christine Fulmer, president; Lois Hindmon Fulmer, secretary; and Abner Allred, vice president. Allred was also the 1947 *Lincolnian* editor. (Courtesy of the Goldstein family.)

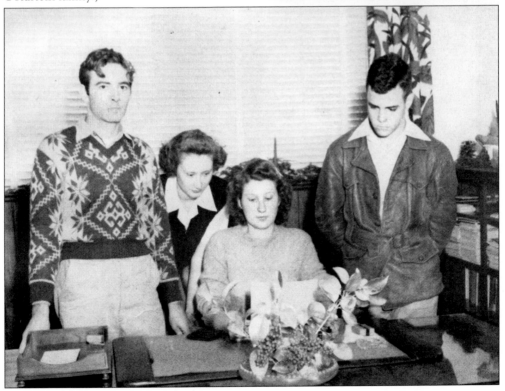

Dewey Williams is fondly remembered by many in Lincoln for the roles he filled while a teacher at Lincoln High School. Whether in driving the #17 school bus, coaching the football team, teaching math, or being assistant principal, he touched the lives of many. Students remember Williams's long bus route and the days when older boys got off at Choccolocco Creek bridge for a swim while the bus took riders down the road, then doubled back to pick up the boys. (Courtesy of the Goldstein family.)

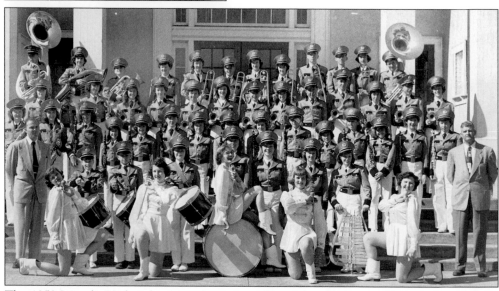

The 1953 Lincoln High School band members, from left to right, are (first row) majorettes Kathryn Patterson, Judy Williams, Nola Kiker, Charlotte Campbell, and Jean Talley; (second row) Charles H. Vickers, director; Macon Ray; William F. Bentley; Janice Vincent; Patricia Smelley; Rita Ackery; Pam Ray; Charlotte Butler; and Hoe York, principal; (third row) Wanda Allen, Geraldine Greene, Billy Sara Parlow, Alma Haynes, Norma Dean Meharg, Connie Jean Davis, Nancy McKay, Mary Emma Hearn, Linda Rowell, Roy McCaig, Judy Hamby, Gee McGehee, Sue Merkl, Johnnie Johnson, and Alline Champion; (fourth row) Jackie Stine, Joyce Crump, Virginia Allred, Nettie Gaither, Marie White, Margret Cole, Carolyn Williams, Ronnie McAdams, Kathleen Haynes, Eugene Sexton, Carey Weldon, Barbara Bentley, Billy Parker, and Margie Parker; (fifth row) Joe Quinn, Bonnie Sue O'Dell, Tommy Whatley, Delano Wier, Doris Pettis, Paul Gaither, Ann Gauldin, Patsye Burton, Charles Champion, John Shaddix, Barbara Goldstein, and Lester Talton. (Courtesy of Barbara Goldstein Bonfield.)

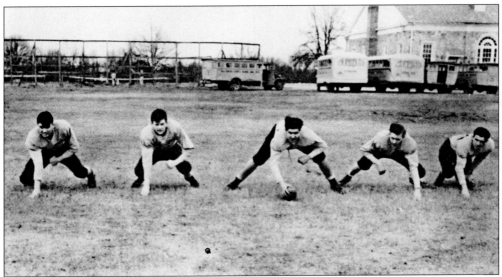

The 1945 Lincoln High School football squad proved to a formidable team, which included, from left to right, the following players: Lindy Cotton, Billy Williams, Fred England, Harold Morgan, and Billy Dorsett. Billy Williams, whose father Dewey Williams coached the team, went on to be the first of several in the 1950s and 1960s who played football on athletic scholarship for the University of Alabama. Billy Williams also played in the All-Star football game at UA and was selected the outstanding player of the game. Note in the background the LHS auditorium building and several school buses, including the "Chicken Coop" bus. (Courtesy of Jimmy Goldstein.)

Today, Paul Ellen, now 75 years old, lives in Auburn and recalls with fondness his days at Lincoln High School. Ellen remembers that he would not have passed typing class if he had not been friends with Bobby Watson: "His aunt, Mrs. Audrey Watson, was the teacher. We were the only two boys in the class, and she wouldn't flunk us." He graduated in 1947 and was a member of the Beta Club. His parents were Luther and Lula Ellen, and his sister, Lella McAdams, still resides in Lincoln. The Ellens ran a dairy farm near Clear Springs. This picture was taken in the auditorium of the school. Ellen has three sons: Paul Jr., Jonathan, and Timothy. Paul Jr. has been a radio announcer for Auburn football since 1971. (Courtesy of Bob Watson.)

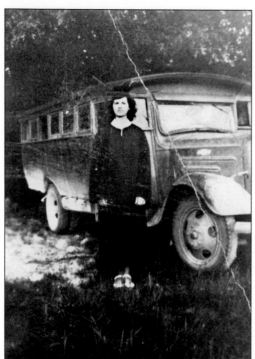

Yetta Goldstein, shown here on her graduation day, stands by the school bus that she rode 18 miles to and from school each day. The bus had benches on each side and one down the middle. It was cold and drafty in the winter and hot and dusty on the dry, dirt roads in the summer, and it frequently got stuck in the mud on rainy days. (Courtesy of Jimmy Goldstein.)

Boy scouts pictured in the 1944 LHS *Lincolnian* annual include, in no particular order, Vernon Chapel, Charles Vaughn, Raymond Lane, Harry Allred, Carl Chappel, Waverly Walker, W.L. Taylor, Charlie Allred, Eugene Allred, Abner Allred, Bobby Watson, Billy Williams, Jimmy Watson, Jack Landhamm, and Dewey Williams, Scoutmaster. (Courtesy of Jimmy Goldstein.)

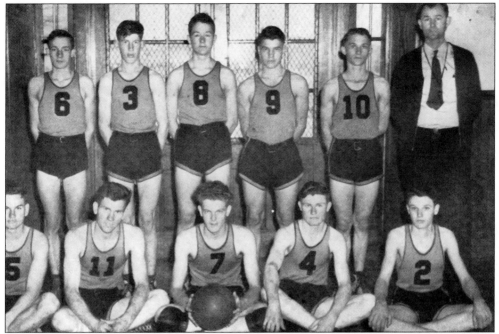

The 1944 basketball team included, from left to right, the following: (front row) James Hugh White, Jay Dorsett, Bill Sullivan, John Frank Nelson, and Ernest Johnson; (back row) Horace Glidwell, J.C. Champion, Obie Williams, Bobby Cummings, Earl Johnson, and Coach Dewey Williams. (Courtesy of Jimmy Goldstein.)

Traditionally, the junior class sponsored a prom for the senior class at Lincoln High School. Students decorated the auditorium and raised funds for food and entertainment. As today, all the girls spent months finding just the right formal dress; in 1960, the dress of choice was floor length with layers of tulle netting over satin and usually a hoop to make the skirt stand out. The boys wore white jackets with a black bowtie or tie. In this April 1960 photograph, seated at the front, left table among others are Mary McCullars and Betty Howell. In the audience was Jimmy Kirksey and future Lincoln mayor Lew Watson. (Courtesy of Mildred Trammell.)

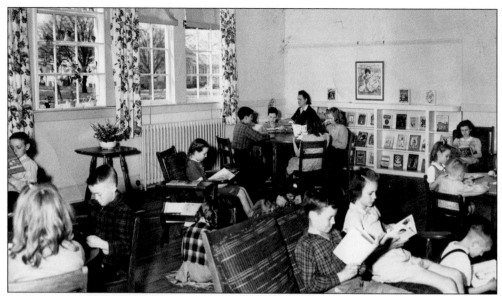

This photograph shows children reading in the Lincoln Elementary School library. Identified students are (left table) Tommy Disspain and Euna Thomaston; Carl Chappell sitting on sofa; sitting at the table with teacher are Betty Watson and Emma Allred; and at the far right table are Ann Coleman, Eleanor Watson, and Charlie Disspain. (Courtesy of Sara Watson.)

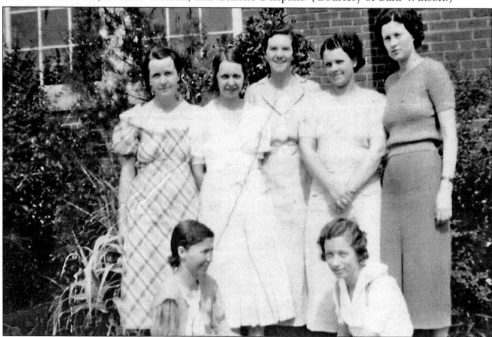

This photograph of the faculty of Lincoln Consolidated School for the 1933–1934 term was taken in the spring near the front entrance. Pictured are, from left to right, the following: (standing) Nan Killough (pronounced "key-ler"), fifth grade; Mary Colvin, first grade; Florence Reynolds, fourth grade; Jane Hobson, third grade; and Dorothy King (later Mrs. Charles Jones), second grade; (kneeling) Nora Fuller (later Mrs. R.M. "Shorty" Hughes), first grade; and Mabel Sloan, sixth grade. (Courtesy of James Grimwood.)

Three
FAMILIES

For I have found that those we love never go away completely. They come back in the moments of our greatest sadness, and our greatest joy. And they always come unexpected.
—Robert Morgan

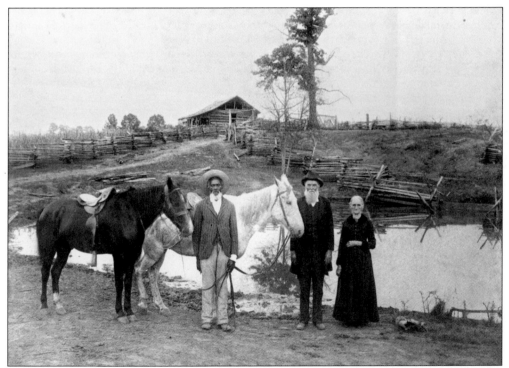

James Zachariah Embry and his wife, Louisa Frances Collins Embry, are shown on their 50th wedding anniversary in October 1892 with Perry Embry. Fifty years earlier, Perry held the horse so that James could row his boat across the Coosa River to get Louisa Frances. They eloped and traveled to what is now Calhoun County to be married. Uncle Perry, as he was fondly known, returned with them to the site where James crossed the river to get Louisa on their anniversary. Uncle Perry was a family slave, but chose to remain with the Embry family after the Civil War. The couple had 17 children and were, at various times, foster parents to 13 other children.

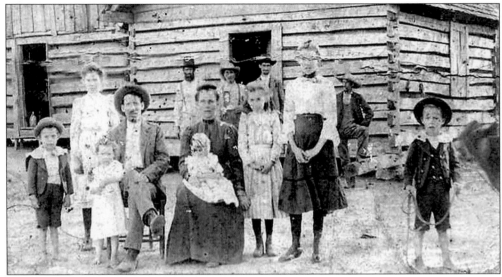

Henry Columbus Champion and his wife Eliza, pictured c. 1910, were longtime residents of the Dry Valley area of Lincoln. They reared 13 children and helped with many of the grandchildren. They were active in Dry Valley Baptist Church, where Henry was a deacon and a song leader for many years. On Sundays, he hooked up the mules to his wagon to ride to church; by the time he arrived, the wagon would be full of worshippers. In the summer, when the church held revivals, the visiting preacher was a guest in the Champion home. Known for his farming and for making sorghum syrup, Henry purchased a new car in the early 20th century with money made from his syrup mill. Eliza was known for her ability to care for and treat the sick. (Courtesy of the Champion family.)

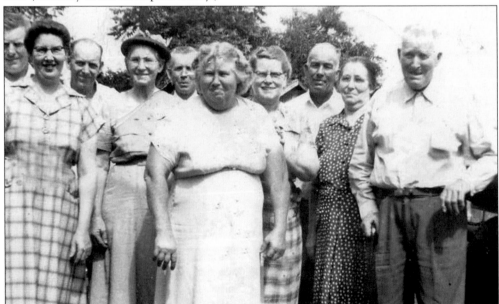

Henry Champion is seen c. 1956 with 9 of his 13 children. Pictured from left to right are (front row) Beulah, Nell Stevens, Dolly Belle Swafford, Pearl, Nancy Nunnally, and Henry; (back row) Clarence, Sara, Luke, and Richard. Neither Pearl nor Beulah married; both stayed home to care for their daddy after their mother died. (Courtesy of the the Champion family.)

This photo made in the early 1920s shows the railroad sign that marked the stop in front of the Embry home place. Pictured are Alden and Victoria Embry. (Courtesy of Goldstein family.)

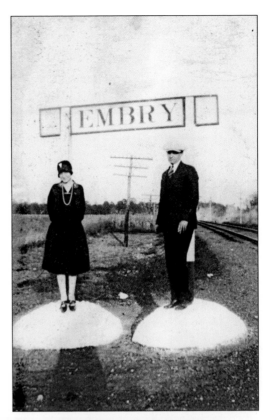

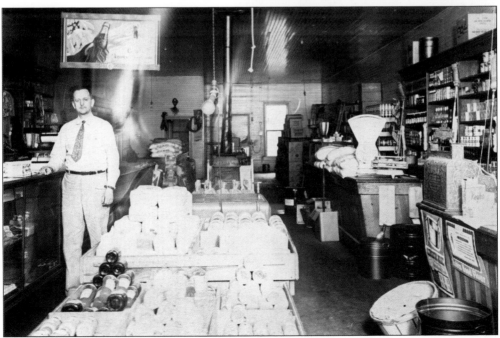

Harry Clay Burns is pictured here in his general store in the late 1940s. The store was located in the downtown Lincoln area. (Courtesy of the Burns family.)

Here are Albert Burton and his son Joe, *c.* 1916. The Burton farm in Refuge has been in the Burton family since 1834. (Courtesy of the Burton family.)

G.L. "Louis" Schmidt (1867–1960) and Inez Cofield (1877–1943) are pictured with their children, Dorothy, Bernard, and Alma, on the porch of their home at Conchardee *c.* 1908. One year later, Louis and W.D. Davis strung telephone lines among three homes at Conchardee, which became the Lincoln Telephone Company. In the early 1930s, Louis's sons, G.L. Jr. and Bernard, installed electric lights at Conchardee using a water-powered generator, believed to be the area's first rural electricity. G.L. Jr., born in 1913, studied architecture in college and designed his home at Conchardee. He also made by hand many of the wood beams and much of the machinery for the new mill, where he was later killed. Though his father had once led the singing in the Lincoln Methodist Church and had played the violin, Dorothy Schmidt recalled never hearing him play after G.L's death. (Courtesy of Laura Cheloke.)

Pictured are Robert Wallace Tuck (1869–1943), his wife Haddie, and her sister Hulda Dora Hudson (1877–1948), better known as Ma Hudson. This photograph was taken in front of what is today known as the Kirksey House, which sits at the corner of 4th Avenue and Jones Street in Lincoln. (Courtesy of Curtis Mitchell.)

A.J. Moseley (1890–1967), pictured with Talladega County agent Sut Matthews, inspects his newest crop of peaches in May 1955. Moseley farmed about 70 acres in Lincoln and usually had at least 7 varieties of peaches. His peaches were famous for miles around, and people came from as far away as Atlanta to buy them. His first orchard began where present-day Fourth Avenue goes over the hill. Moseley Park, at the intersection of U.S. Highway 78 and Alabama Highway 77, was sold to the City of Lincoln to help establish the park. A.J. and his wife, Ethel, were members of the Lincoln United Methodist Church and lived on Chestnut Street, adjacent to the Dr. Gus Colvin home. The Moseleys had two sons, Robert and Jenkins. They are buried at Lincoln cemetery. (Courtesy of the Mosely family.)

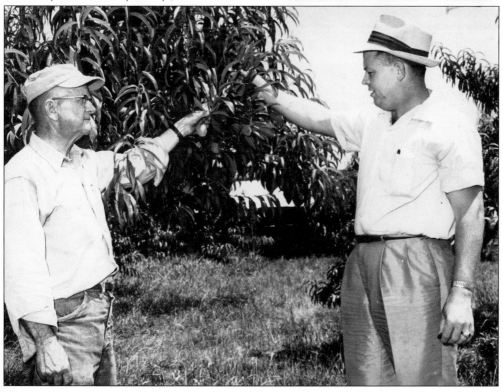

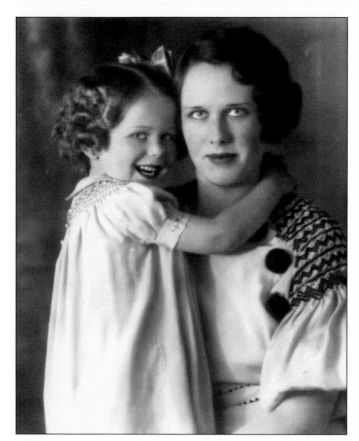

Pictured c. 1932 are Maudie Mae Phillips Burns and her daughter, Joan Burns Huffstutler (1929–2000). Joan was very active in community and civic organizations and initiated meetings to organize a historic group in Lincoln, which later became the Historic Lincoln Preservation Foundation. (Courtesy of the Burns family.)

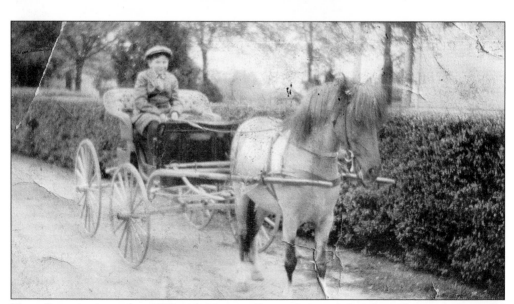

Harry Burns is pictured c. 1910 with his pony Buster. It is said that the only person he would allow to ride in the buggy with him was his neighbor and friend Louise Sullivan. (Courtesy of the Burns family.)

Luada Embry, granddaughter of Eddy and Fannie Embry, is clad in her Sunday dress. Note the locket around her neck and white gloves on her hands. (Courtesy of the Goldstein family.)

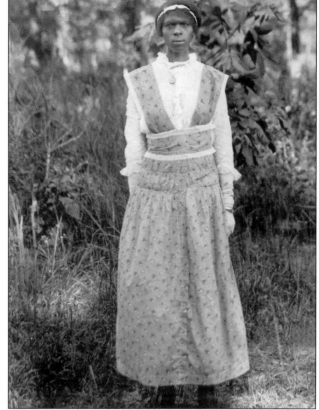

Haddie Tuck sits next to her sister, Ma Hudson, standing. Ma Hudson was known for boarding mules for the government for 25¢ per day when Lock Four was built in the early 1900s on the Coosa River. (Courtesy of Curtiss Mitchell.)

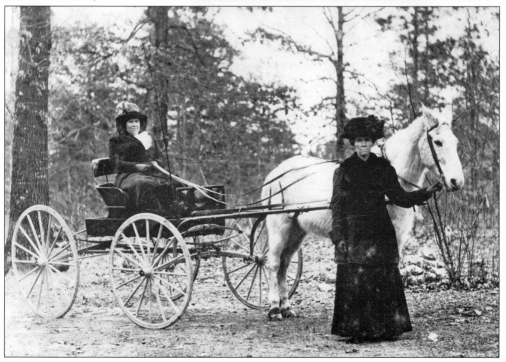

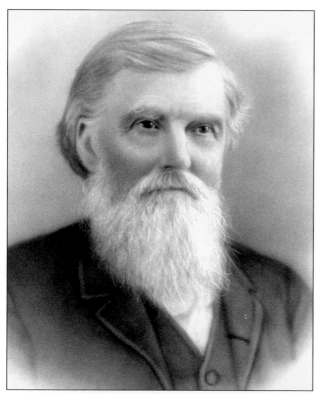

James Zachariah Embry, son of Elijah Embry, was one of the first settlers in Talladega County. James established his home at what became known as Embry's Crossroads when he negotiated with the Georgia Pacific Railroad *c.* 1882 to add a stop on his property so that his family could travel to and from Birmingham. For many years, the Embry family was able to flag the train at the crossroads. (Courtesy of the Goldstein family.)

Taken *c.* 1890, this photograph is of Leopold Merkl and his wife, Louisa Knorr Merkl. Leopold was a priest in Bamberg, Germany, and Louisa was a nun. They migrated to America in 1847, and all of the Lincoln Merkl family can trace their ancestry to this couple. (Courtesy of the Merkl family.)

Sudie Schmidt, born at Conchardee in 1869, was the only daughter of Bernhard Schmidt and Permelia Harmon. In 1913, Sudie built a home on Magnolia Street in Lincoln where she taught school. Her "country" nieces and nephews lived with her during school terms. Sudie was much loved by her family; in fact, when she was engaged to marry a tavern owner in Talladega—but her family did not approve—Sudie called off the engagement and never married.

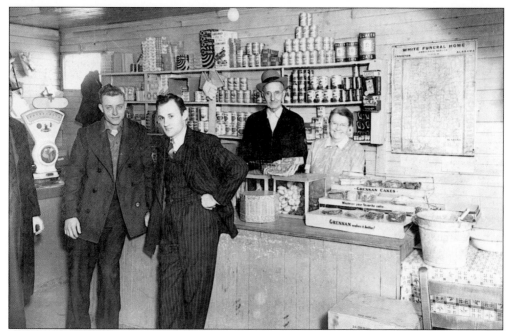

Lee Mitchell and his wife, Mag (behind the counter), sold dry goods and bus tickets at their store on U.S. Highway 78. This photograph, taken in the late 1930s, shows three strangers waiting for the Greyhound bus. Ollis Madden, a frequent shopper at the store when he was young, recalls purchasing a bus ticket to Talladega for 25¢ round trip. Note the neatly stacked shelves stocked with cans and Quaker Oats. Also, notice the White Funeral Home map hanging on the wall and the Grennen Cakes on the counter. (Courtesy of Curtiss Mitchell.)

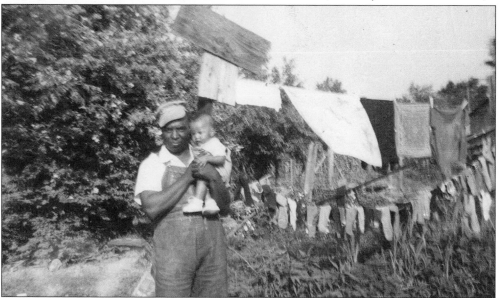

Pictured here are Sidney Fomby Sr. and his grandson Rodney Fomby at their home in Lincoln in May 1958. Note the wash hanging on the line. Sidney Sr. was a charter member of the Lincoln Civic Action Committee and was known to serve God, his family, his church, and his fellow citizens. (Courtesy of Sidney Fomby Jr.)

In the late 1890s, Thomas Disspain moved to Lincoln with his wife, Elizabeth, and their son, James Leroy. Thomas was the railroad section foreman for the new Georgia Pacific Railroad. The Disspain family lived in a section house near the railroad and went on to have eight other children: Mae, Pearl, Mildred Grace, Ruby Tom, David, Helen, Birdie, and Opal Ruth. Mildred Grace and Opal Ruth died as children. Thomas was known for his honesty and for his meticulous bookkeeping. An entry in one of his railroad records says: "Unloaded 10 rails; 8 angle bars (used); 4 base plates and 6 bolts, November 18, 1925. Will use on my miles 749–753." Thomas built a home for his family on Magnolia Street but died before he could move into it. A newspaper article dated March 30, 1926, says, "T. Disspain died at home Saturday night. . . . Mr. Disspain was well known and liked by all who knew him. He was one of the best section foremen that the Southern Railroad had." Seventeen descendents of Thomas and Elizabeth Disspain still reside in Lincoln today; many are active in the Historic Lincoln Preservation Foundation. (Courtesy of Mildred Trammell.)

Members of the England family are shown in 1954 at their home on Fourth Avenue. Pictured from left to right are (seated) Mrs. F.P. England; (standing) Charles England, Mr. and Mrs. J.L. England, Mirian England Whitley, and Fred England. (Courtesy of Charles England.)

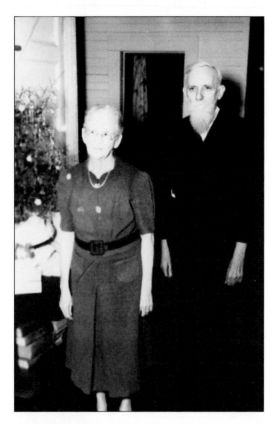

T.J. and Helen K. Watson are shown in the Watson House foyer at Christmas 1949. The couple married in 1895 and, soon afterward, built a house in Eureka, where Helen's family lived. Their children were Flora Watson (Landham), Jenieve Watson (Ellis), Byron, Robert, Kennedy, John, and Russell. Around 1915, the Watsons built a home on Magnolia Street across from the new Talladega County High School so that the three oldest children could enroll. In 1919, T.J. bought the John L. Law house from the Law's estate and moved his family into what is today known as the Watson House. Continuously occupied by a member of the Watson family until 2000, the property was then purchased by the Historic Lincoln Preservation Foundation. (Courtesy of Bob Watson.)

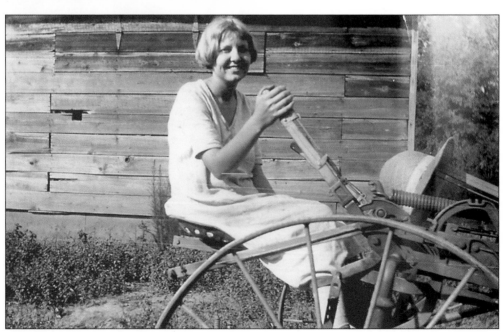

Kate Hollingsworth Merkl, c. 1920, was known county-wide for her writings in the *Talladega Daily Home* newspaper. She died in 1982. (Courtesy of Merkl family.)

This c. 1890 photograph includes members of the Hitt family. They are identified, from left to right, as Granddaddy Hitt, Uncle Charlie Hitt, and Grandma Hitt. The family lived in the Embry Cross Roads area. (Courtesy of Annis Ledbetter.)

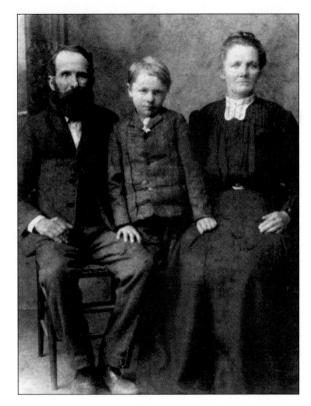

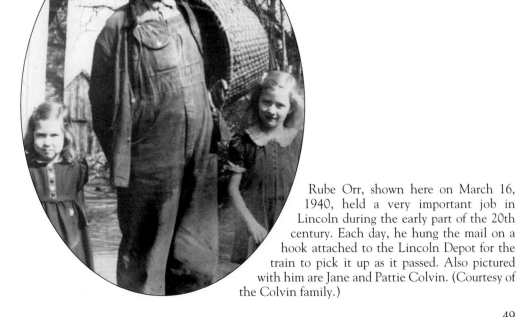

Rube Orr, shown here on March 16, 1940, held a very important job in Lincoln during the early part of the 20th century. Each day, he hung the mail on a hook attached to the Lincoln Depot for the train to pick it up as it passed. Also pictured with him are Jane and Pattie Colvin. (Courtesy of the Colvin family.)

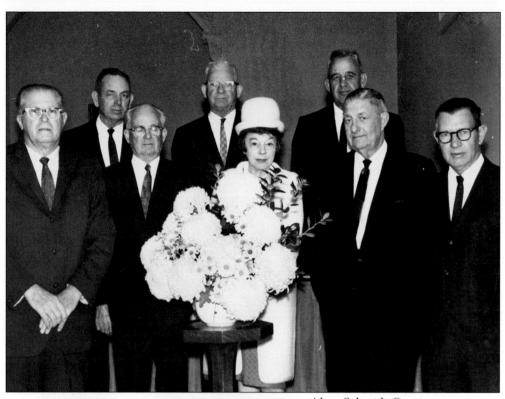

Alma Schmidt Coggins (1899–1990) is shown with the men's Sunday school class at Lincoln United Methodist Church, which she taught for many years. Pictured are, from left to right, Pat Patterson, J.D. Hubbard, Robert Watson, Kennedy Watson, Alma, Frank Woods, unidentified, and ? McGehee. Alma worked for many years as a social worker in Talladega and was very popular. (Courtesy of Laura Cheloke.)

Mildred Disspain Trammell and her sister Frances Disspain Bowman are pictured *c.* 1949 near the family mailbox in Dry Valley. Today, both are charter members of the Historic Lincoln Preservation Foundation. Mildred serves as the foundation's president. (Courtesy of Mildred Trammell.)

Pictured from left to right are Louise Montgomery (Sullivan), her brother Earl Montgomery, and Willie Dee Green (Watson). Earl, a local attorney, was known in later years to drive to his office in Talladega with his socks hanging out the window to dry. He also liked to load up his goats and carry them in his car. The photo is undated. (Courtesy of HLPF archives.)

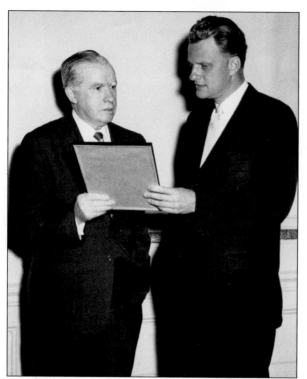

Burl S. Watson (left) is pictured with Billy Graham as Billy joined the New York Southern Society. Burl was born in Lincoln on November 7, 1893, and was the first graduate of Lincoln (Talladega County) High School in the spring of 1913. He went on to graduate from the University of Alabama and became chairman of the board of Cities Service Corporation. He was respected and known worldwide as a man of great accomplishments. Burl married Emitom Burns, sister of Robert and Harry C. Burns. (Courtesy of Margaret Mongold.)

Inez Martin is shown here on the Franklin farm. (Courtesy of Kathryn Fain.)

Warney Burgess, pictured here in the early 1950s, operated a rolling store in the 1940s. He is remembered as a kind, loving man who gave away as much as he sold. (Courtesy of Annis Ledbetter.)

At their home in Eureka, the Burgess girls pictured are, from left to right, Elvie, Faye, Kitty, and Mary Anne. (Courtesy of Annis Ledbetter.)

Dr. Gus Colvin, son of Dr. J.P. and Addie Colvin, was born near Eureka on the Choccolocco Creek in 1899. As a boy, he accompanied his father on house calls in a horse-and-buggy. Later, Dr. Gus, as he was affectionately known, graduated from Tulane Medical School and interned at Mercy Hospital in New Orleans. He started practicing medicine with his father in 1928. He married Mary Evelyn Clark of Red Level; they had three children. An avid fox hunter and conservationist, he was full of jokes (he became a legend in the area for his joke-telling) and enjoyed life immensely; when it came to his patients, however, he meant business. He served the Lincoln community faithfully until his death in 1975. (Courtesy of the Colvin family.)

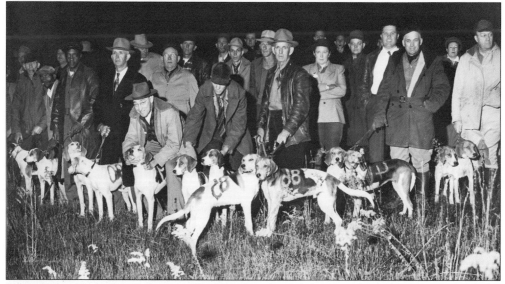

Pictured here are the Colvins with their friends and hunting hounds. (Courtesy of the Rozelle family.)

Dr. James Picket Colvin was born in Butler County in Greenville, Alabama, on March 20, 1864. He was the son of Col. Charles Henry Colvin and Mrs. Olive Pickett Colvin. In 1892, James married Addie McRae. He attended medical college in Mobile and moved to Lincoln when he heard the community needed a physician. He practiced medicine in Talladega County for about 32 years. He was one of the last doctors in the area who made house calls in a horse-and-buggy. During the early years, there were few antibiotics. Lacking the medicine that we have today, James spent more time with his patients. He was known for his wit and personality and told fascinating stories, which were sometimes the only tonic for a sick patient. (Courtesy of Colvin family.)

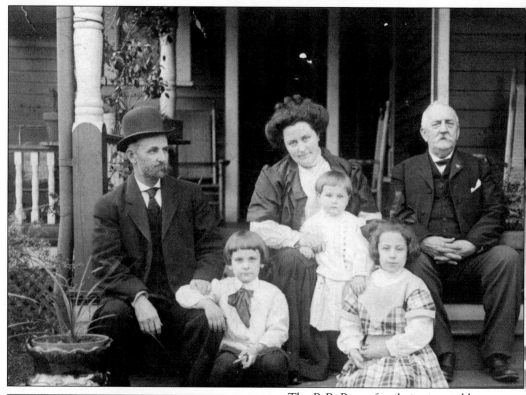

The R.B. Burns family is pictured here
c. 1905 on the steps of the House of
Seven Gables on Magnolia Street.
Shown are, from left to right, Robert
Benjamin; his wife Angie Lee Goff
Barry; their children Robert, Harry, and
Emitom; and Angie's father Thomas
Barry. Theodore Burns, R.B.'s father,
was one of the founders of Lincoln. He
and his wife Elizabeth were the parents
of five children, all born in Lincoln:
Samuel Pinckney, Melissa Adelaide,
Mary Wallace, Frances Embry, and R.B.
(Courtesy of the Burns family.)

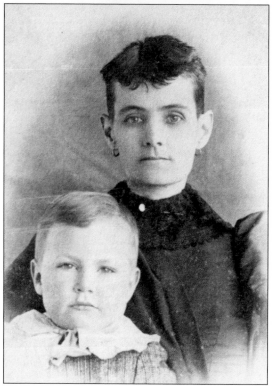

In this photograph are Thomas Olin
Brooks and Mary Wallace Burns, called
Aunt Mamie. Although the photograph
is undated, it is known that Thomas
Olin was born on March 4, 1891.
(Courtesy of Teresa Brooks.)

Mildred Roberts was the daughter of Frank and Sallie Johnson, owners of the classic Queen-Anne, two-story, Victorian home located on Magnolia Street. Mildred was born in the home in 1917 and lived there her entire life. She married William (Bill) Roberts and taught at Lincoln Elementary until she retired. Mildred and her husband had one daughter, Gene. Bill served on the Lincoln City Council for 17 years and was elected mayor pro-tem in 1967 when Mayor Kennedy Watson became ill. (Courtesy of HLPF archives.)

This rare snowfall c. 1935 offered a chance for young friends to play together during the cold winter months. Pictured with Willie Dee Watson are her sons Abee (sitting on the car) and Bobby and their playmates Bill Sullivan and Roy Tarber. This photo was taken at the house on Magnolia Street. (Courtesy of Bob Watson.)

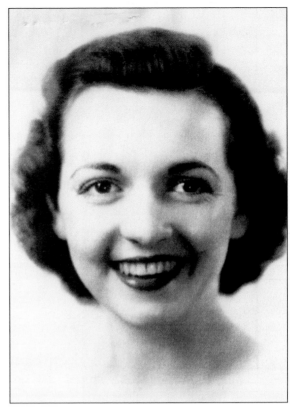

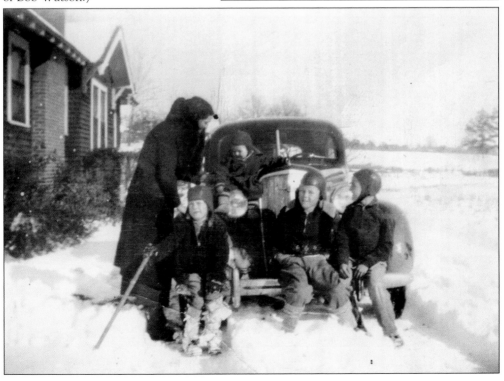

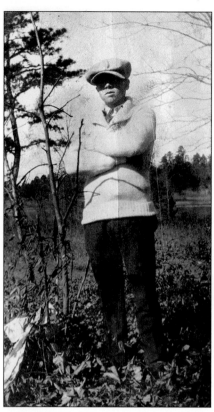

Dewey H. Franklin (1906–1981) is pictured on the Franklin Farm near today's Honda Manufacturing of Alabama plant on U.S. Highway 78. Dewey was probably 18 years old in this photograph. (Courtesy of Katherine Fain.)

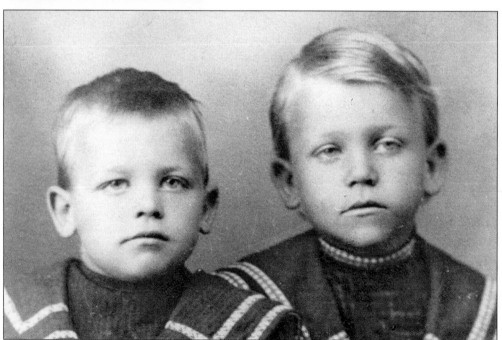

This c. 1905 photograph features Eldred T. Merkl (left) and his brother Frank M. Merkl. The boys were the sons of Eugene G. and Matilda Hall Merkl. (Courtesy of the Merkl family.)

Marion Embry Gaston, daughter of
Luada Embry and great-granddaughter
of Eddy and Fannie Embry, is shown
here with her son Chuck. Marion grew
up in Embry's Bend, near her great-
grandparents. (Courtesy of the
Goldstein family.)

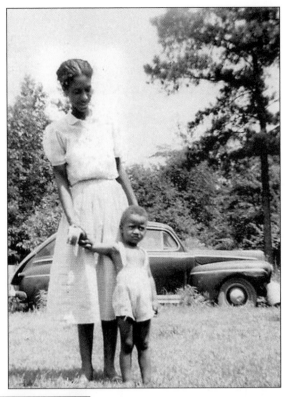

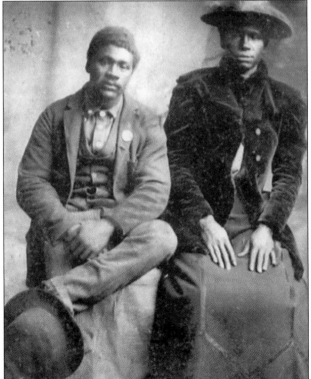

Pictured here are Eddy and
Fannie Bryson Embry. Fannie
descended from slaves who lived
on the Bryson plantation in
Mississippi. Uncle Eddy and
Aunt Fannie, as they were
affectionately known, lived in
Embry's Bend, where Eddy
farmed and harvested herbs from
the nearby woods. (Courtesy of
the Goldstein family.)

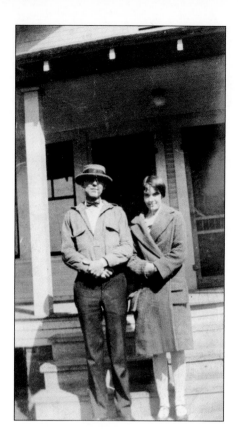

Pitt and Birdie Disspain Parker stand at the Disspain home on Magnolia Street in Lincoln c.1930. (Courtesy of Joyce Varnes.)

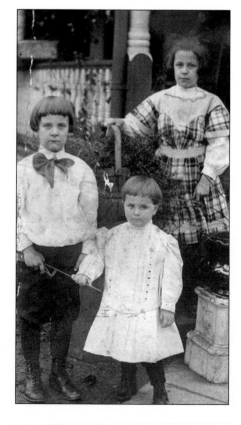

Pictured in this c. 1906 photograph, from left to right, are Robert Lee Burns, Harry Clay Burns, and Emitom Burns Watson, all of whom are the children of Sen. Robert Benjamin Burns and his wife Angie Lee Goff Barry Burns. Emitom married Burl Watson, Harry married Maudie Mae Phillips, and Robert married Eva Gray Phillips. (Courtesy of the Burns family.)

The three oldest children of T.J. and Helen Watson are, from left to right, Byron, Jenieve, and Flora. (Courtesy of Betty Watson Bullock.)

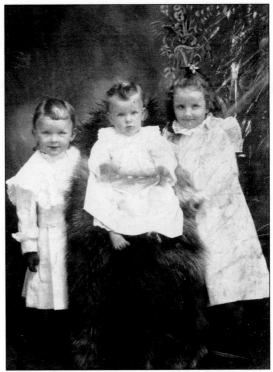

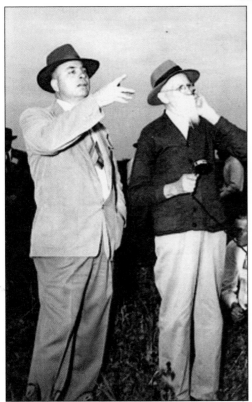

T.J. Watson, a large-scale farmer and successful businessman, was known as the "granddaddy" of the re-seeding crimson clover. He discovered growing on his farm a strain of clover that would re-seed each season. It was from this strain that he developed and distributed the most widely-used source of hard-seed crimson clover in the South. Crimson clover was used for winter grazing, soil building, hay, and seed production. With a Talladega County farm agent, Watson showed his clover fields to visiting farmers from across the Southeast. One of his first business ventures was a partnership in the England, Watson, and Love general goods store. In 1935, he bought out his partners and formed a partnership known as T.J. Watson and Sons with sons Byron, Robert, Kennedy, and Russell. T.J. was also a banker, farm equipment dealer, cotton ginner, and an automobile dealer. The Watson family acquired thousands of acres of land over the years. Later, hundreds of acres were sold for the construction of the Honda Manufacturing of Alabama plant, located on U.S. Highway 78. (Courtesy of Bob Watson.)

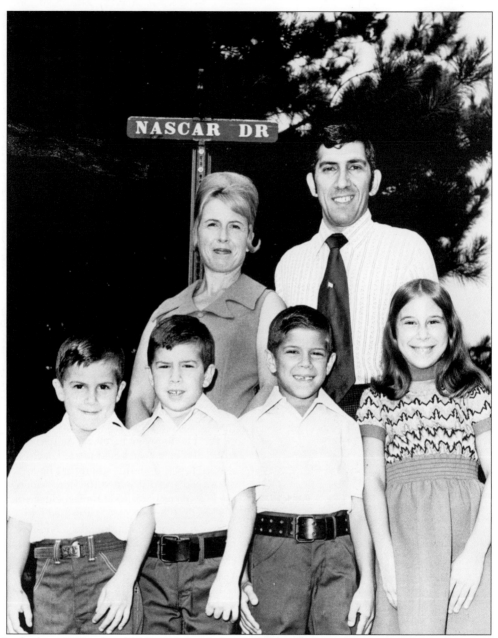

In the late 1960s when NASCAR decided to build the Alabama International Speedway near Lincoln, people were all abuzz about the possibilities of growth. To show the town's appreciation to NASCAR, then mayor Raymond Martin and the city council named a street in a new residential section of town NASCAR Drive, the first in the country. "Lincoln is growing quickly thanks to the nearness of the speedway and its customers, and sight-seers bring approximately $1 million to the area each year," said Martin in a press release dated August 12, 1971. "Of course, without NASCAR, there would be no speedway here or in any other town of such size. This is our small way of showing our appreciation." Shown at their home on NASCAR Drive are, from left to right, the following: (front row) Joseph, Kevin, Donald, and Sharon Naman; (back row) parents Joanne and Don Naman. (Courtesy of Naman family.)

The Disspain children pose here, *c.* 1947, across the road from the Talladega International Superspeedway at their cousins's home. Pictured are, from left to right, the following: (seated) Mildred and Dave Jr. (Doot); (standing) Charles and Jim. (Courtesy of Mildred Trammell.)

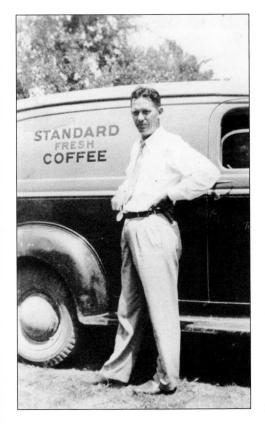

The Standard Coffee man was a mainstay for housewives in the 1940s and 1950s in Lincoln and the surrounding countryside. In addition to coffee, the man sold blankets, small appliances, and cooking utensils. He made rounds once a week. (Courtesy of Joyce Varnes.)

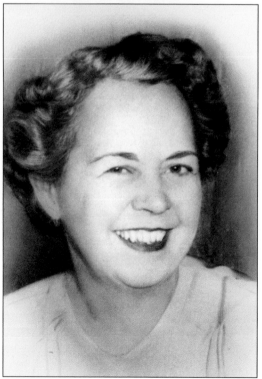

Ophelia Burks moved to Lincoln to teach in the new Lincoln Elementary School. She met and married Byron Watson in 1928 and lived on Magnolia Street until her death in 1980. Ophelia taught for several years at the elementary school and raised their daughter Betty Byron. Ophelia was a founding member of the Lincoln Quest Club and a dedicated member of Lincoln Baptist Church. She was known as a wonderful baker of cakes, which she delivered to the homes of friends who were ill or had suffered the loss of a loved one. Byron, the eldest son of T.J. and Helen Watson, attended the University of Alabama for three years but was called home by his father to help with the family businesses during a minor depression in 1920 when cotton prices dropped drastically. Byron was a cashier at the First National Bank of Lincoln until the banks closed in the early 1930s. He served as Lincoln postmaster for 32 years. (Courtesy of Betty Watson Bullock.)

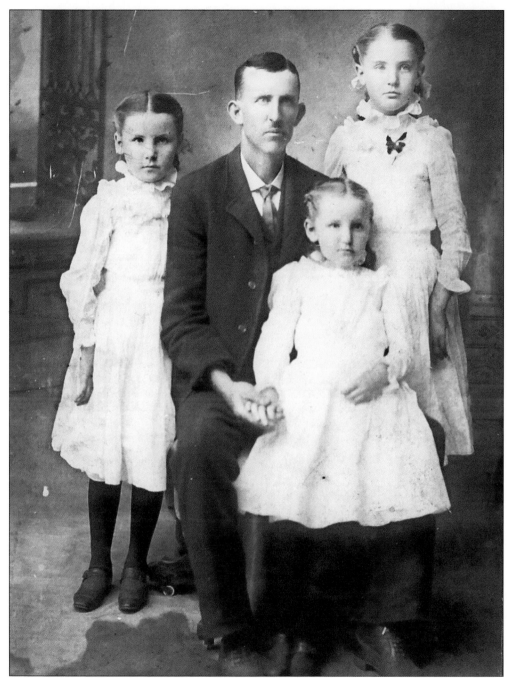

Seated in this *c.* 1905 photograph are Thomas C. Hollingsworth and his daughters, from left to right, Viola, Clara, and "Sid." Three Hollingsworth sisters married three Merkl brothers, thus creating a family with multiple double cousins. Viola married Washington L. Merkl, while Clara married William Rex Merkl. Not shown is Kate, the other sister to marry a Merkl brother. She married Eldred T. Merkl. (Courtesy of the Merkl family.)

Jimmy Kirksey is pictured here on Christmas morning c. 1947. (Courtesy of HLPF archives.)

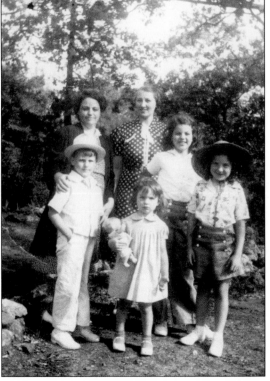

Margaret Embry Goldstein is pictured with her family—Jimmy, Barbara, Yetta, and Sarah—and a friend, Terese Ahten Schmidt (center back), at Schmidt's Mill, c. 1940. Margaret's grandparents, James and Louisa Frances Embry, lived near Lincoln. Margaret lived with her husband Sam and their children in Embry's Bend. Sam was born in Chienchow, Poland, and came to America in 1903. Terese Schmidt was born in Ditzum, a small fishing village in Germany on the Ems River. She came with her parents, Lauardus Ahten and Tibini Dreesmann, and her brother, Diedrich, to America in 1929 and lived at and farmed the old Linden place on Stemley Bridge Road in Talladega. The family went back to Germany in 1936, and in 1937, Terese returned to marry Bernard Schmidt. The Goldsteins and the Schmidts became lifelong friends. (Courtesy of Laura Cheloke.)

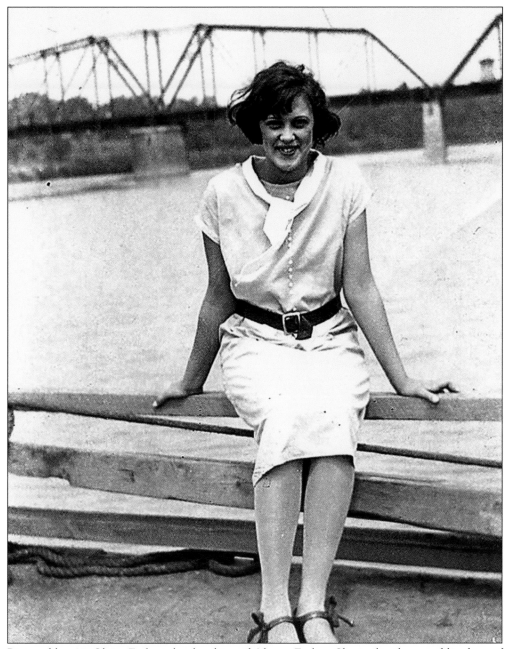

Pictured here is Claire Embry, the daughter of Alonzo Embry. She is also the granddaughter of James Zachariah Embry. This photograph was taken on the Coosa River near Riverside. Note the train trestle in the background.

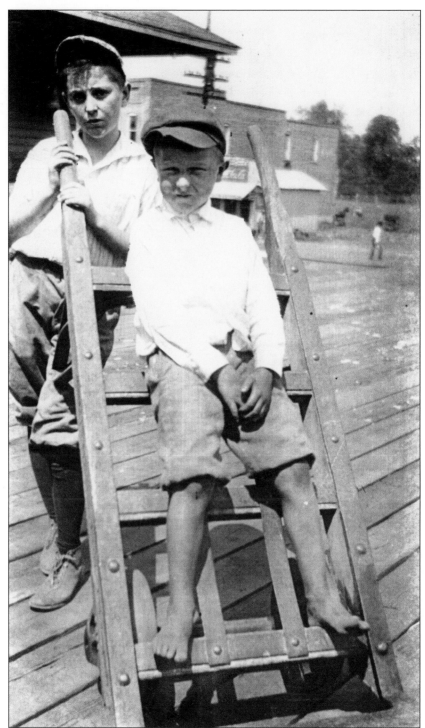

Bill Montgomery (right, on the ladder) and his boyhood friend and playmate Harry Burns are pictured on the platform of the Lincoln Depot *c.* 1914. Note the now-destroyed Lincoln drug store in the background. (Courtesy of HLPF archives.)

George Ludwig "Ludy" Schmidt Jr. (1913–1935) was the youngest child of G.L. Schmidt and Inez Cofield. Born at Conchardee, he attended the Conchardee and Talladega County High Schools. Ludy lost his life in an accident at the mill. When he dove underwater to work on a turbine, his foot slipped and his leg was caught and severed in the turbine. He managed to swim to the surface, tie off his leg with a leather belt, and crawl for help. He was rushed to the hospital and seemed to be recovering, but he died from gangrene two days later when medicine did not arrive in time. He was 21 years old and engaged to be married. Also in the photograph at far right are Marshall Allred (left) and an unidentified man. (Courtesy of Laura Cheloke.)

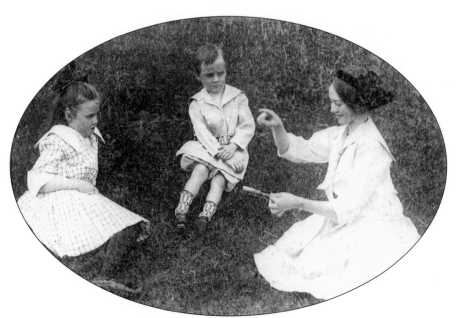

The children of G.L. and Inez Schmidt, pictured here at Conchardee c. 1910, are, from left to right, Dorothy, Bernard, and Alma. (Courtesy of Laura Cheloke.)

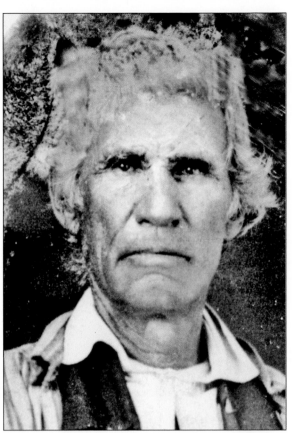

Jeremiah Collins, father of Louisa Frances Collins Embry, was a prominent landowner throughout Talladega County. (Courtesy of the Goldstein family.)

This undated photograph features, from left to right, Ola, Clara, and Sid Hollingsworth, children of Tom and Sue Hollingsworth.

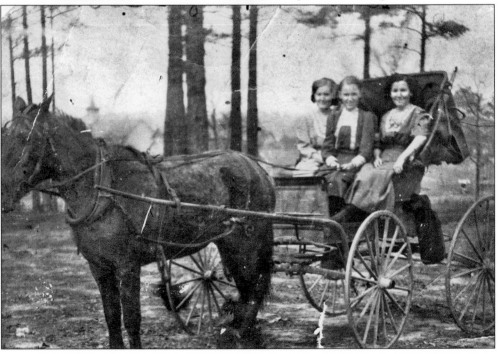

Carl Bernhard Schmidt (left) and his brother Georg Ludwig Schmidt are pictured in New York City. Bernhard was born in Plauen, Saxony Germany in 1831, came to America in 1853, and arrived in Talladega County in 1859, where he managed Jemison's Grist Mill and ran his own farm. He fought in the Civil War, came home on leave to marry Permelia Harmon, and was later captured by the Union Army "because," he always said, "my damn horse wouldn't jump." After the war, he and Jacob Harmon built a grist mill at Conchardee. Bernhard and Permelia had two children, George Ludwig and Sudie. Bernhard's older brother Georg, who immigrated before he did, was a contractor in New York City, where his name is still inscribed on some of the streets and sidewalks he paved. (Courtesy of Laura Cheloke.)

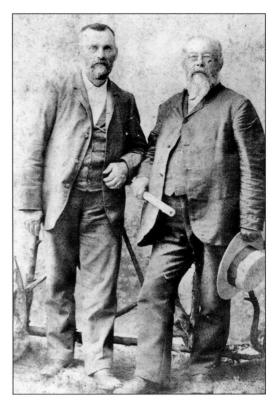

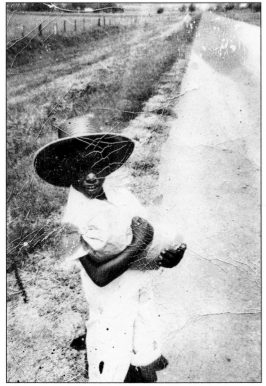

This little boy, carrying a sack of meal from Schmidt's Mill, is thought to be a member of the Gaddis family who lived near the Houston farm. The photo was taken near the Choccolocco Creek Bridge on the old, one-lane Lincoln-Talladega Road. Ragland Mountain is in the distance. Though the photo is undated, it is known to have been taken after 1937. (Courtesy of James L. Colvin.)

John Cox was a Lincoln mail carrier who, for many years, delivered the mail in a horse-and-buggy. His oldest son Red, who also delivered the mail in Lincoln, was known for being very active in the Lincoln community. Red Cox Memorial Stadium, the football field used today by Lincoln High School, was named for him. One of John's other sons, Bam, played football for the University of Alabama. (Courtesy of Agnes Bentley.)

Members of the Bentley family from Dry Valley, pictured here c. 1949, are William Bentley; his wife, Agnes (Cox) Bentley; and their children Barbara Ann, William "Ferrell," and Charles Eugene. (Courtesy of Agnes Bentley.)

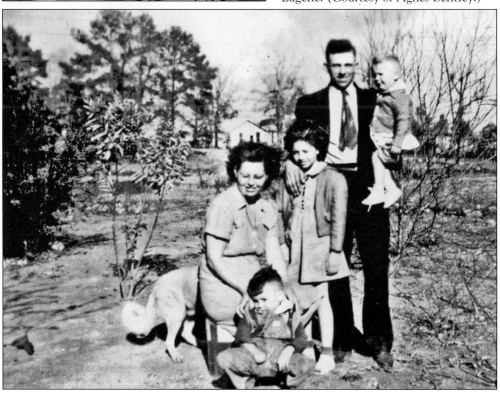

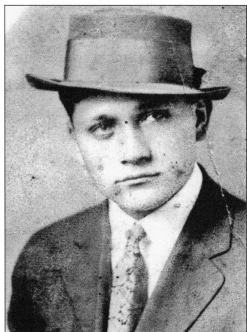

(*above left*) Henry Cox, born in 1890, married May Virginia Merkl. He died during the influenza outbreak in 1918 at the age of 28. (*above right*) Featured in this photo is Lee Cox, brother of Henry, Jim, and John. (Courtesy of Agnes Bentley.)

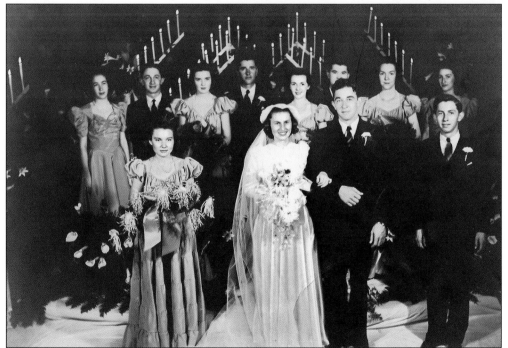

The bride and groom shown here on their October 5, 1940 wedding day are Montine Dickinson and Ed Rozelle. They were married at Lincoln United Methodist Church, had a reception at the Burns home, and honeymooned in California. (Courtesy of the Rozelle family.)

James Colvin Phillips (left) is pictured with his mother, Adena Davis Phillips, and sister, Maudie Mae Phillips (Burns). (Courtesy of the Burns family.)

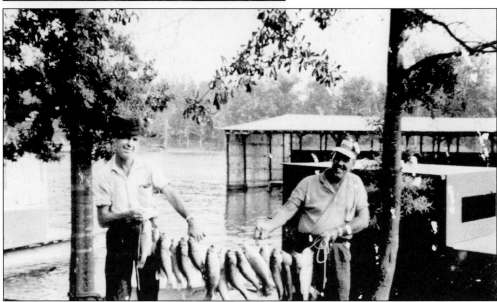

Newman Whitfield (left) and an unidentified man made quite a catch on this day *c.* 1965 at 78 Boat Dock. There are 16 bass on the stringer. In the years just after Logan Martin Lake was created, the Smelley family held bass fishing tournaments from the boat docks. Before the water was backed up, the Smelleys ran a dairy farm on 130 acres. The lake took 40 acres of their property, and 78 Boat Dock still operates today, though not on the scale it once did. (Courtesy of Pat Pike.)

Guy Gannaway, a longtime farmer from the Embry Bend area of Lincoln, is shown here in his later years with an extra large watermelon he grew at his home. In the 1950s, Gannaway was one of the first farmers in the area to purchase a self-propelled combine. A 1951 newspaper article said, "Guy Gannaway, who farms 600 acres near here . . . bought a self-propelled combine for the staggering sum of $6,600." (Courtesy of the Burton family.)

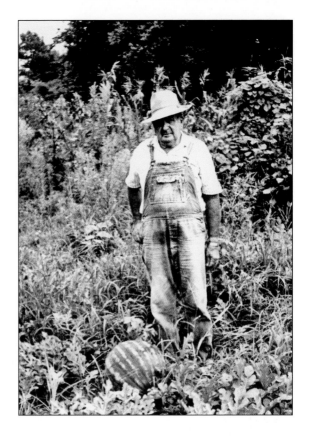

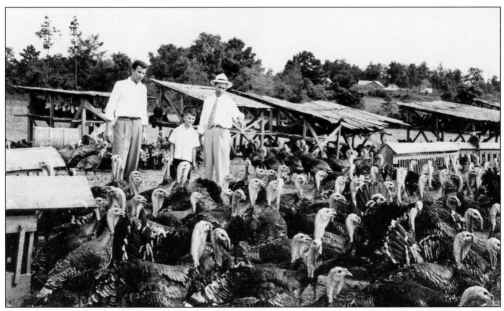

Young Joe Burton is shown here with a flock of turkeys on his family's farm in Lincoln. John Weeks, the A.P.I. Extension poultry man, points to an especially nice young bird in the flock owned by B.A. Burton. The photo was taken *c.* 1935. (Courtesy of the Burton family.)

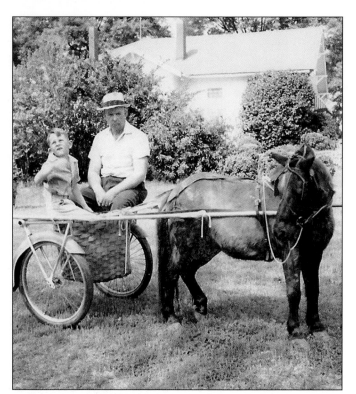

Mark Rozelle (left) is shown here with J.O. Davie. Mr. Davie built carts for his ponies and often gave kids a ride in them (Courtesy of the Rozelle family.)

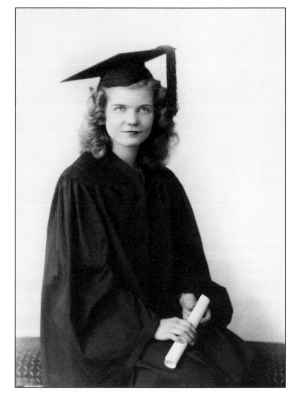

Sarah Watson poses for her high school graduation photograph. Sarah came to Lincoln in the early 1950s after marrying Thomas Robert (Bob) Watson. She was a beloved teacher and principal at Lincoln Elementary School from 1953 to 1985. (Courtesy of Bob Watson.)

Mrs. J.L. (Hollie) Hollingsworth was a charter member of the Lincoln Quest Club. Organized in 1934 and federated the same year, Lincoln Quest Club held its first meeting on February 28, 1934, and is the longest-running club in Lincoln. The club's purpose is to promote the social and intellectual welfare of its members. Charter members included Charlotte Burns, Bessie Carpenter, Bertha Clotfelter, Myrtle Dickinson, Jenieve Ellis, Hollie Hollingsworth, Bessie Hollingsworth, Wallace Jones, Ivie Thompson, Flora Landham, Ethel Moseley, Mamie Richey, Ophelia Watson, Willie D. Watson, Birdie Davis, Dot Hatchett, and Evelyn Williams. The membership is limited to 18. (Courtesy of Lincoln Quest Club.)

Grown children of James Zachariah Embry, pictured in 1924 are, from left to right, the following: (front row) Elizabeth Embry Kennedy; her daughter Frances "Fantoe" Kennedy; Lula Box Embry, wife of James Alden Embry; Magnolia Embry; and A.J. Carlos "Doc" Embry; (back row) grandson Alden Embry; granddaughter Renfro Embry; and Martha "Mat" Embry Hall. (Courtesy of the Goldstein family.)

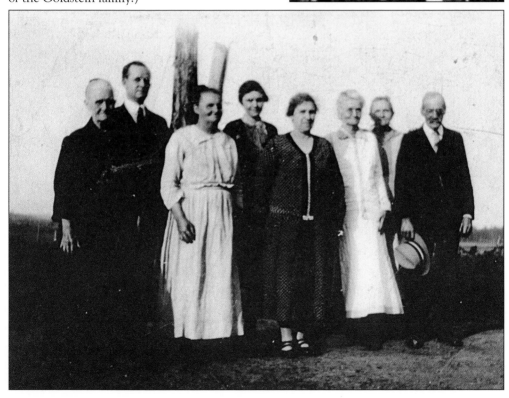

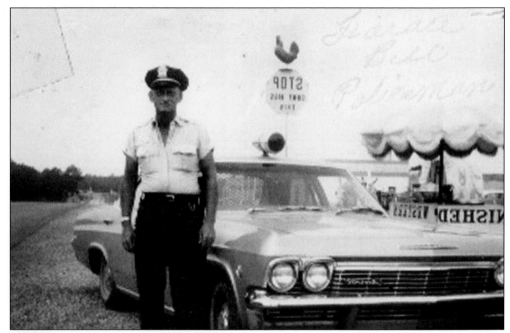

When Lincoln Police Chief Horace Bell resigned in the late 1960s to take a job at Clow Manufacturing Company, he had worked for the city for nine years and had headed up a two-man, one-car force. "We're looking for another police chief right now," said Mayor Raymond F. Martin in an interview with the *Talladega Daily Home*. Bell was making $325 a month. "It's a real problem. We do need to strengthen our law enforcement. You can imagine what's going to happen here next," said Martin. The mayor was referring to the opening of the "Alabama International Speedway, a gigantic stock car raceway under construction near here," as was stated in *Talladega Daily Home*. (Courtesy of HLPF archives.)

William Franklin (right), born in 1903 on the Franklin farm, is pictured here in his swimsuit. The other man is unidentified. (Courtesy of Kathryn Fain.)

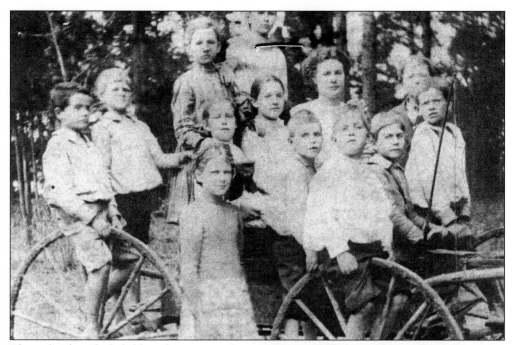

The only identified child in this group is Jenieve Watson (Ellis), standing in front. (Courtesy of Betty Watson Bullock.)

Jenieve Watson (Ellis) is shown here in her 90s. Her husband, John Ellis, was a well-known area farmer, an official with the Coosa Valley Electrical Co-Op, and a director at the Talladega National Bank in Lincoln. He was selected to appear in the 1969 edition of "Outstanding Personalities of the South." The Ellises lived on a farm in the Eureka area. Jenieve was involved in the Eureka Women's Club, in addition to being a full-time bookkeeper for the T.J. Watson partnership. (Courtesy of Betty Watson Bullock.)

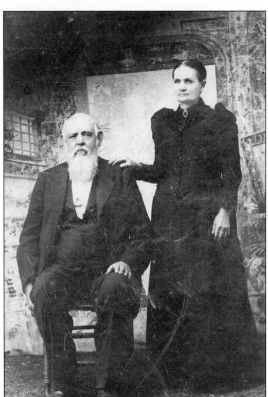

Pictured here are Dr. and Mrs. Alpheus Olin Brooks. Mrs. Brooks was Frances Embry Burns, the sister of Sen. R.B. Burns and the daughter of Theodore and Elizabeth Burns. (Courtesy of Teresa Brooks.)

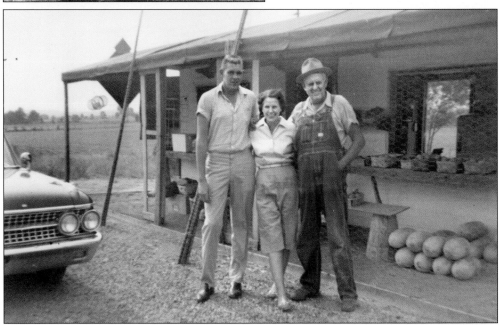

The Smelley family poses here at the curb market on Highway 78 West near 78 Boat Dock. Pictured are, from left to right, Jerry, Troy, and Foster Smelley. The store sold oil, gas, fishing equipment, and vegetables from the family garden in the spring and summer. (Courtesy of Pat Pike.)

This recently discovered photograph of Elizabeth Disspain and her son Dave was taken c. 1919. Note Dave's missing left-hand fingers. When he was six years old, Dave picked up a dynamite cap near Lincoln Elementary School. It exploded in his hand, resulting in the loss of three fingers. (Courtesy of Mildred Trammell.)

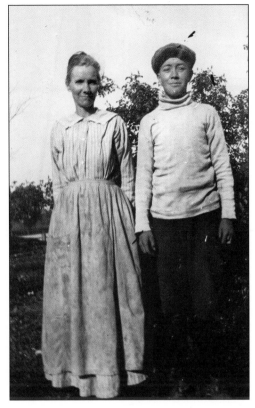

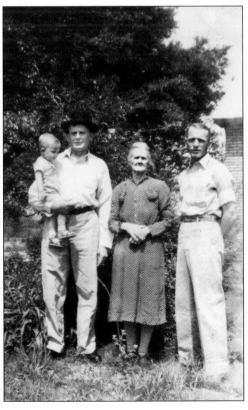

Representing four generations of the Vincent family in 1944 are, from left to right, Mrs. John Vincent, T.W., Ernest, and Shannon. (Courtesy of Connie O'Dell.)

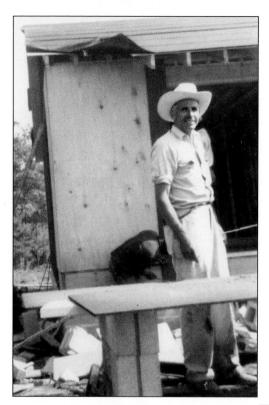

Carroll Watson Sr. built most of the homes in Lincoln in the 1950s and 1960s. He served on the city council and was part of a progressive team of citizens during that time. He worked on the Battleship *Alabama* prior to its service in the Pacific during World War II. Carroll was married to Ruth Potts for nearly 40 years, and their son, Carroll 'Lew' Watson Jr., is the current mayor of Lincoln. (Courtesy of Lew Watson.)

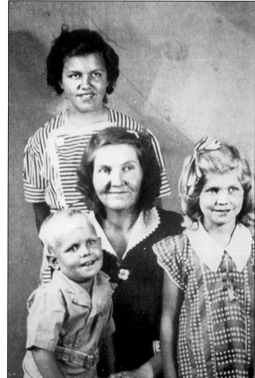

In this 1940 photograph are, from left to right, Doris Helen Merkl, Eldred D., Kate (Hollingsworth), and Sara (standing). (Courtesy of the Merkl family.)

J.D. Thompson was a mechanic in Lincoln for many years. (Courtesy of Bob Watson.)

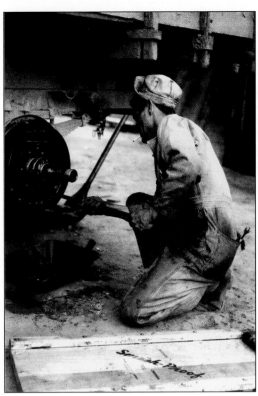

Unis Dickinson and an unidentified woman sit in a buggy in downtown Lincoln. Note the Lincoln Depot and railroad tracks in the background. (Courtesy of Bob Watson.)

Shown in the 1947 *Lincolnian* are Louise Burford and James Hugh White. They were chosen as senior class favorites. Burford was active in school, participating in the Glee Club, the 4-A Club, and FHA, and she played on the girls basketball team. White was a football and basketball player. (Courtesy of Bob Watson.)

Members of the Vincent family are pictured in this *c.* 1914 photo. From left to right are (front row) Margie Phillips (Carlisle), Bill, Martha Josephine Sullivan Vincent, Pat, and John W. Vincent; (back row) Evie Vincent Phillips, Robert, Wallace, Thomas Wicker, and Louie Vincent. (Courtesy of Connie O'Dell.)

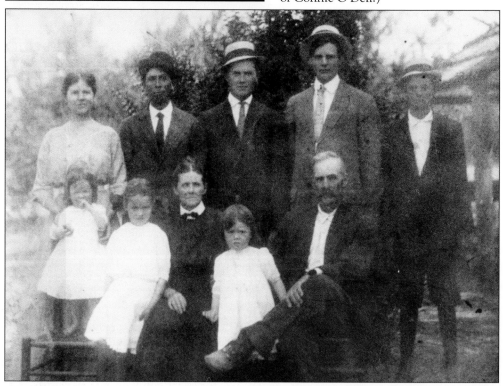

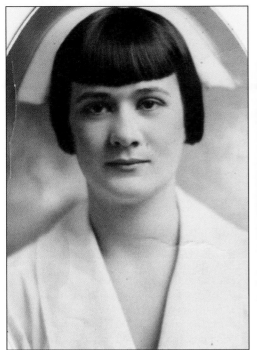 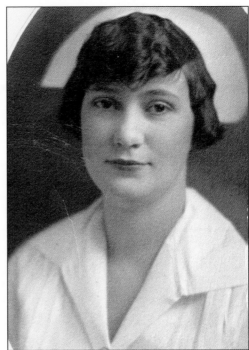

(*above left*) Mary Brooks (Dewberry) is pictured here in 1924. She graduated from South Highlands Hospital nursing school and married in 1926. (*above right*) Elizabeth Brooks (Wright) is pictured here in 1925. She also graduated from South Highlands Hospital nursing school in 1925. (Courtesy of Teresa Brooks.)

Bo Brooks, pictured here *c.*1942, ran a grocery and general merchandise store in downtown Lincoln, adjacent to the railroad tracks, until the early 1980s. (Courtesy of Teresa Brooks.)

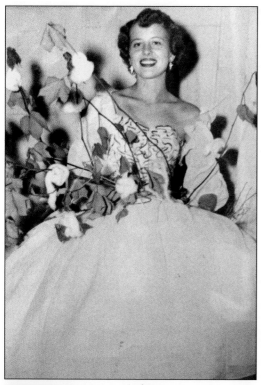

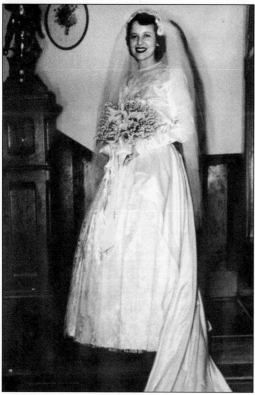

Joan Burns (Huffstutler) was a beloved native of Lincoln. The daughter of Harry and Maudie Mae (Phillips) Burns, Joan graduated from the University of Alabama in 1950, married not long after, and began many years of service to statewide health care. She was recognized across the state of Alabama and the country for her work in health education and as a volunteer for many organizations. She was chosen as a 'Bama Beauty in 1949 while at the university and was selected as the 1950 Maid of Cotton for Talladega County. In 1974, she was listed in "Who's Who of American Women" and was Mobile's Club Woman of the Year in 1968. She is pictured above as the Maid of Cotton and below in her wedding gown on the staircase inside the Burns home, "the Oaks." Joan's mother crafted both gowns. (Courtesy of the Burns family.)

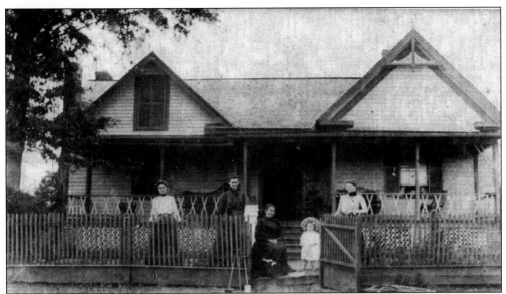

The home of Bernhard Schmidt and Permelia Harmon was built *c.* 1880 at Conchardee. This *c.* 1901 photo shows, from left to right, the following: unidentified, Sudie Schmidt, Permelia, Alma Schmidt, and Inez Cofield Schmidt. (Courtesy of Laura Cheloke.)

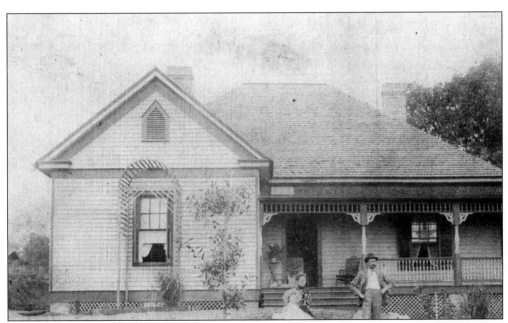

G.L. Schmidt and Inez Cofield stand in front of their home with their daughter Alma and an unidentified man, possibly Inez's brother. This photo was taken *c.* 1901 at Conchardee. (Courtesy of Laura Cheloke.)

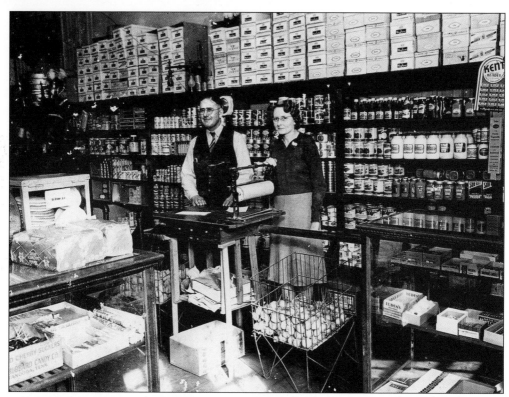

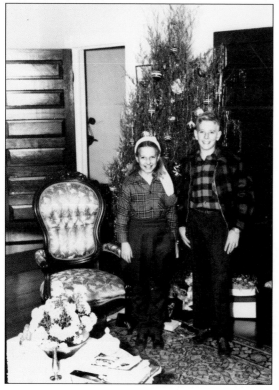

England's store was located in the old First National Bank building in downtown Lincoln. Shown are Mr. J.L. England and his sales clerk Lura Baugh. Note the onions and potatoes in the baskets and the Luden's cough drops in the showcase. (Courtesy of the England family.)

Charlotte and Clayton Davie pose here on Christmas in 1948. The family lived on Magnolia Street in the former Sudie Schmidt home. Their parents were James Otis and Zula Yongue Davie.

Frances Embry Burns, born August 20, 1868, married Dr. Alpheus Olin Brooks. They were parents to seven children: T.R., Tom, Euclid, Sam, Elizabeth, Mary, and George. (Courtesy of Teresa Brooks.)

Brooks brothers T.R., born in 1889; Tom, born in 1891; and Euclid, born in 1895, are three of the seven children of Dr. A.O. and Frances Brooks. (Courtesy of Teresa Brooks.)

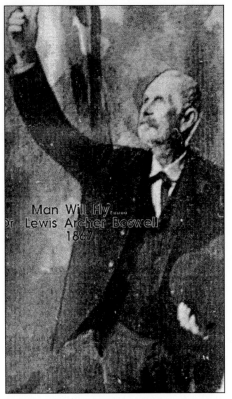

Man Will Fly...... Dr. Lewis Archer Boswell 1867

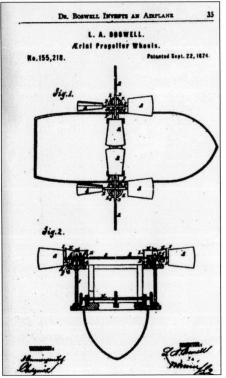

L. A. BOSWELL.
Aerial Propeller Wheels.

No. 155,218. Patented Sept. 22, 1874.

Fig.1.

Fig.2.

Lincoln was the home of a leading pioneer in aviation. According to neighbors and people who worked with him, Dr. Lewis A. Boswell built and operated a flying machine in the early 1870s. Dr. Boswell, a native of Virginia who graduated from the University of Virginia and Jefferson Medical School in Philadelphia and studied further at Johns Hopkins University, was certain that a heavier-than-air craft could be developed. He remained fascinated with the possibility for the rest of his life. Dr. Boswell's wife inherited a plantation near Lincoln, and the couple came there to live in 1869. He designed and made several flying machine models. On April 4, 1874, he applied for a patent for "Improvement in Aerial Propeller Wheels." The patent was granted in September 1874. He continued to work on the design and, in 1903, he received a patent on the steering mechanism. Neighbors testified to the fact that they saw the machine fly, but Dr. Boswell was never able to successfully document this achievement. His fighting in the Civil War and serving the military ruined his fortune, and as Boswell spent more time on his invention than on practicing medicine, he did not have sufficient income to realize his dream.

Four

SERVICE TO
OUR COUNTRY

*Sons loyally went to the country's call
Knowing, of course, that some would fall*
—Mercale DeShazo Whorton

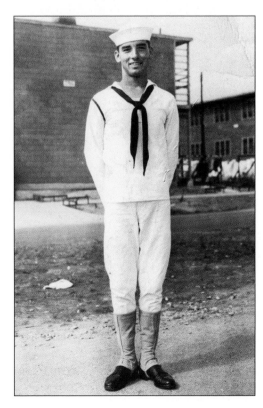

Seaman First Class Robert Lloyd Champion,
the son of Mr. and Mrs. Richard Champion
of Lincoln, is still considered "missing
in action" from World War II. A graduate
of Lincoln High School, he entered
the U.S. Navy on July 4, 1943, and was
declared missing January 20, 1944. He was
last heard from on December 26, 1943,
when he was in England. His ship, the USS
Summer I Kiball, was torpedoed and
destroyed by the German army in the North
Atlantic. Robert was 19 years old. (Courtesy
of the Champion family.)

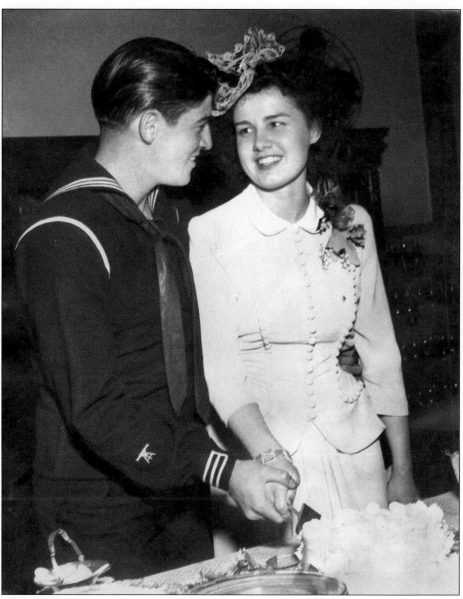

This April 1944 photograph of Lincoln's James Grimwood and his bride Hilda Jernigan received a lot of press attention when it appeared in *The Birmingham News*. The couple, who had planned for almost two years for a wedding at Birmingham's Calvary Baptist Church, was instead married in the USO lounge at the Terminal Train Station in Birmingham with fewer than two hours notice. Jimmy's leave from the U.S. Navy had been cancelled, and he had telegraphed his bride-to-be that he would have only a 35-minute stop en route to San Francisco. When the bride arrived at train time, she found an altar arranged with bride's roses and candles, as well as a reception planned for her guests, all hastily telephoned at the very last minute. After the ceremony, the couple was showered with rice, boarded the train, and was off to San Francisco within the 35-minute time frame. Jimmy, who lives today with Hilda in Houston, Texas, is the son of Mr. and Mrs. H.H. Grimwood of Lincoln. (Courtesy of the Grimwood family.)

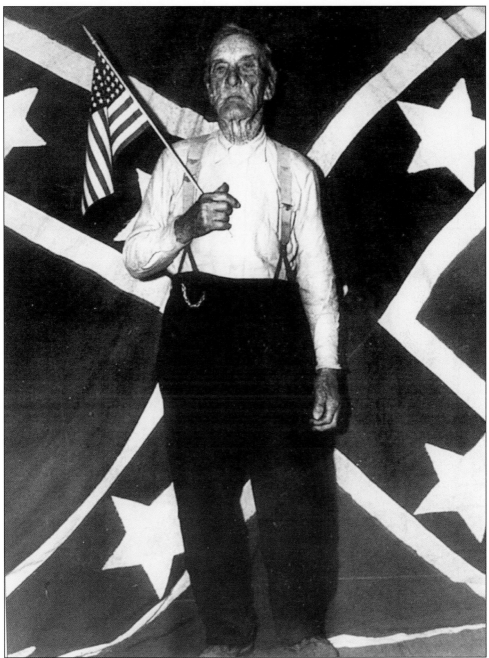

The thin gray line disappeared completely on December 31, 1951, when Col. P.R. (Riggs) Crump, the last surviving Confederate veteran in the state of Alabama, died at 104 years old. Born in St. Clair County on December 23, 1847, Riggs went into the Confederate Army during the latter part of the war and was standing in the ranks at Appomattox, Virginia, when Gen. Robert E. Lee surrendered in April 1865. Crump was a member of Company A of the 10th Alabama Infantry. Uncle Riggs, as he was affectionately known, was a quiet, God-fearing man. He hewed the rafters and sawed the lumber for the house he built and lived in for 80 years. He is buried at Refuge's Hall Cemetery. (Courtesy of the Crump family.)

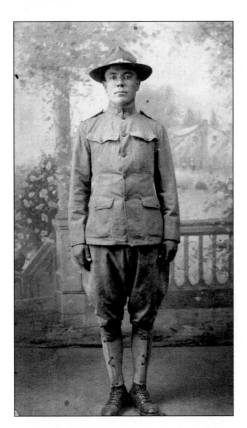

Roy Disspain, killed in action September 13, 1918, became Lincoln's first casualty during World War I. He served in France for fewer than four months and died just 60 days before the Armistice was signed. Roy was the oldest son of Thomas and Elizabeth Dispain and is buried in the Lincoln cemetery. (Courtesy of Mildred Trammell.)

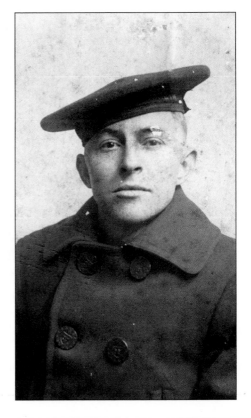

Charles Henry Colvin, the oldest son of Dr. James P. and Adelaid McRae Colvin, was active in the U.S. Navy in World War I. This photo was taken in 1914. Henry attended St. John's College and married Alma Schmidt, daughter of G.L. and Inez (Cofield) Schmidt, in 1920. The couple had four children: James Ludwig, Charles Henry Jr., Mary Alston, and Dorothy McRae. Henry worked at the mill store at Conchardee and spent many hours fishing on the creek. His daughter Mary remembers him as a loving father who always made her laugh. He died in 1952. (Courtesy of James Colvin.)

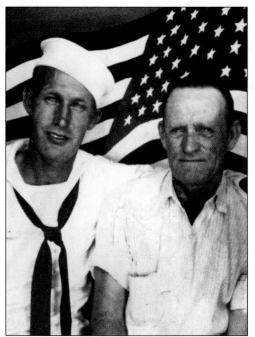
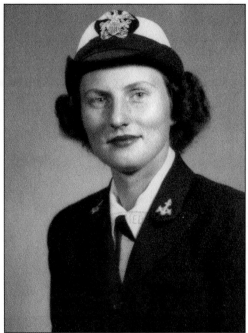

(*above left*) Pictured here are Melvin "Mel" Kiker (right) and a friend. Melvin served in the U.S. Army in World War I in France and Germany. (Courtesy of Anis Ledbetter.) (*above right*) Montine Dickinson Rozelle is pictured as a Navy WAVE (Women Accepted for Volunteer Emergency Service).

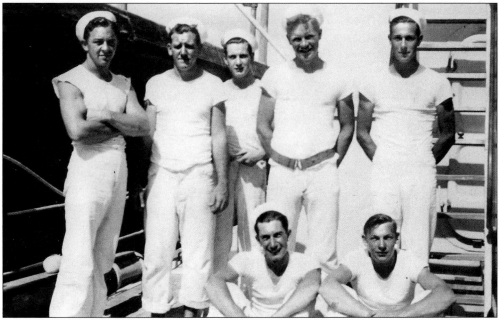

Ed Rozelle (far left) is on board the USS *Houston*. He served before World War II, but when Pearl Harbor was bombed, he went to re-enlist with the stipulation that he again be assigned to the *Houston*. The Navy could not guarantee it, so he instead joined the Army Air Corp. Early in the war, the *Houston* was bombed and sunk in the Java Sea. (Courtesy of the Rozelle family.)

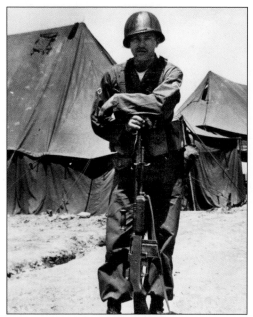
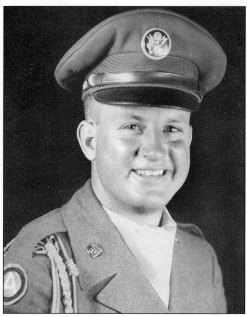

(*above left*) William (Billy) Parker, pictured here in May 1952, served in the Korean Conflict in the U.S. Army. He was wounded July 22, 1952, and received a Purple Heart and a Bronze Star. (Courtesy of Joyce Varnes.) (*above right*) James Alden "Jimmy" Goldstein served in the U.S. Army in 1956. He was stationed in Korea. (Courtesy of the Goldstein family.)

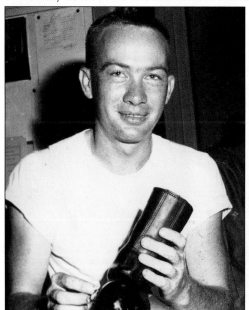
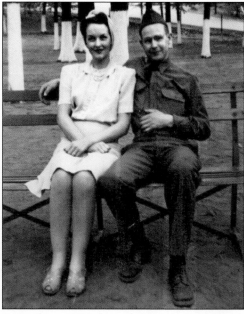

(*above left*) Charles Disspain served in the U.S. Army from 1959 through 1961 at Ford Hood, Texas. He sent this photograph home to his parents, Dave and Audrey Forrest Disspain, with these words on the back: "The boys stay jealous, because I shine my boots all the time and keep them shining better than theirs." (Courtesy of the Disspain family.) (*above right*) Bo Brooks is pictured with his sister Frances Brooks Hannah; he served during World War II in the army in the Philippines. (Courtesy of Teresa Brooks.)

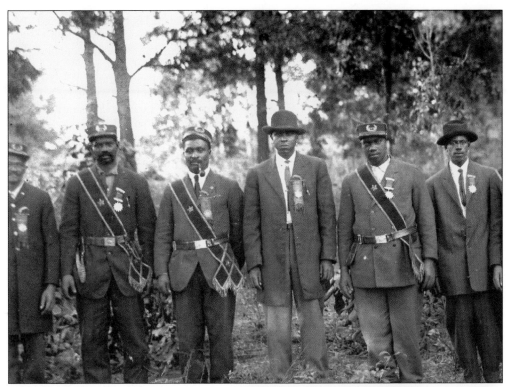

The only identified member in
this World War I African-American
army unit is Irvin Posey (first on left)
from Lincoln. (Courtesy of the
Goldstein family.)

Earnest "Son" Vincent served in the
U.S. Army during World War II. His
company was nearly destroyed by the
Germans; Son and seven others were
the only survivors. (Courtesy of
Connie O'Dell.)

Thomas Robert (Bob) Watson served in Germany in the U.S. Army from October 31, 1950, through September 1952. The son of Robert and Willie D. Watson and the grandson of T.J. Watson, he is a charter and active member of the Historic Lincoln Preservation Foundation and provided many photographs and facts for this publication. (Courtesy of Bob Watson.)

Sonny and Annis (Kiker) Ledbetter pose at the back of the Vincent store near U.S. Highway 78 and Magnolia Street. Sonny was in the National Guard when he was called to the Korean Conflict in 1951. He served for three years. In this photograph, Annis was 17 years old. Note the car on the highway and the Kimberly home in the background. Later, Sonny was a fire chief for the City of Lincoln for more than 20 years. "He filled a gap for us," said Lincoln mayor Carroll "Lew" Watson Jr. "He made sure the people of Lincoln had adequate fire protection for many years." (Courtesy of Annis Ledbetter.)

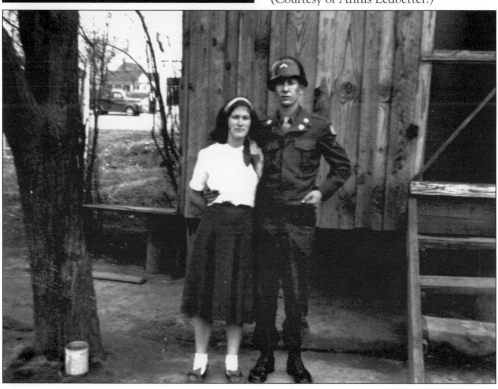

Joe Watson served in the U.S. Navy and was a fighter pilot in the Pacific during World War II. Later, he worked for Delta Airlines. (Courtesy of Bob Watson.)

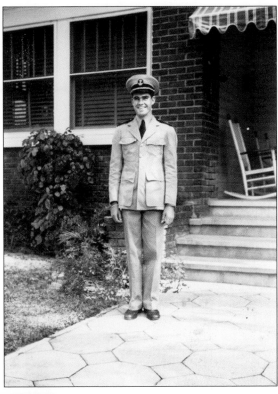

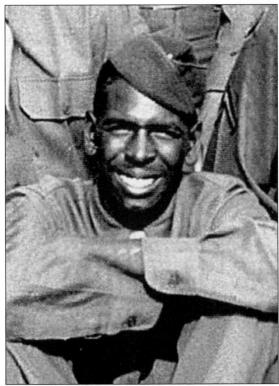

Leonard Fomby Jr. served in the U.S. Army during World War II. He is the son of Luada Embry and grandson of Eddy and Fannie Embry. (Courtesy of the Goldstein family.)

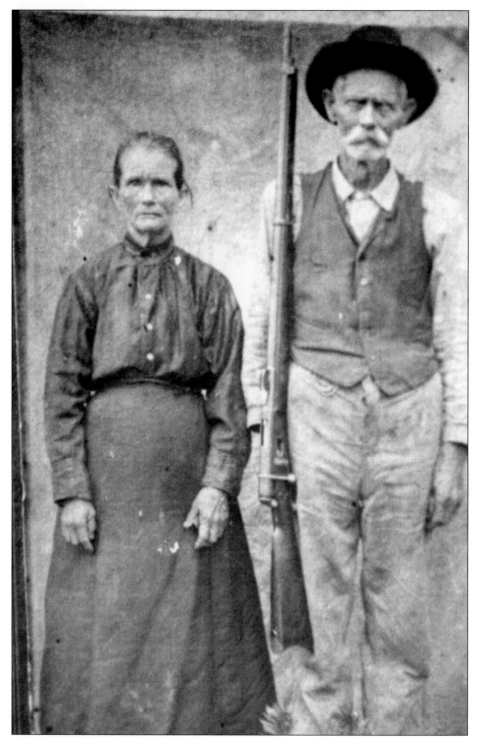

This *c.* 1890 photograph features James (Tom) and Theodosha (Doshie) Wadsworth Hall. James served in the Civil War where, it is believed, he used the gun seen in the photograph. Both Tom and Doshie are buried at Dry Valley Cemetery. (Courtesy of the Merkl family.)

Five

PUBLIC SERVICE

"I never forget that I serve the people . . . and that I have been given their trust."
—President Franklin D. Roosevelt

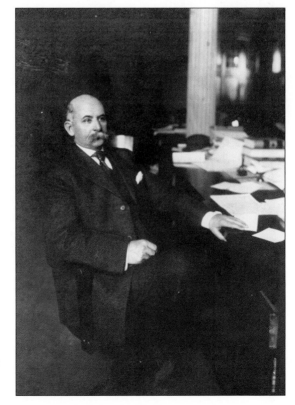

Sen. Robert Benjamin Burns was born January 2, 1864, in Lincoln. He was a leader in the incorporation of Lincoln in 1911, served on the city council, and was instrumental in locating Talladega County High School at Lincoln. In 1915, he was elected to the Alabama Senate representing the Eighth Senatorial District. Senator Burns was a merchant and cotton buyer in Lincoln for over 50 years. (Courtesy of the Burns family.)

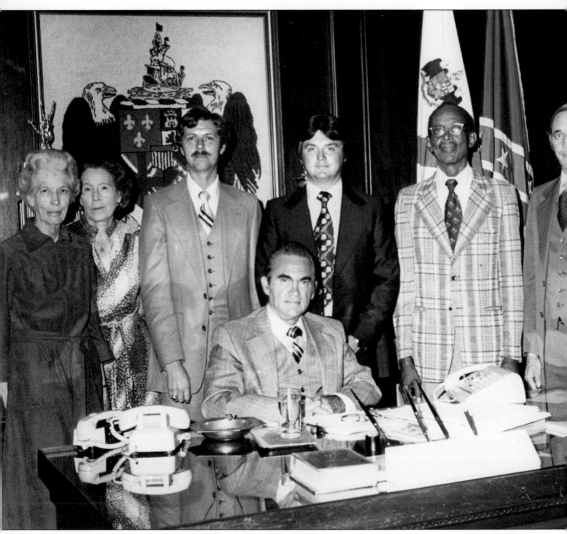

In the mid-1970s, Lincoln was in need of a city park. Moseley Park was born from a push by the Lincoln City Council (shown here) and the Moseley family. Pictured are, from left to right, the following: Mary Henderson, Troy Smelley, Lew Watson, Ray Pettus, David Jones, and Rep. Gerald Dial. Gov. George C. Wallace, seated, provided $15,000 toward the park's construction. David Jones, elected in the 1972 municipal election, was the first African-American official elected in Talladega County. Mary Henderson, whose father W.D. Henderson was Lincoln's first mayor, served four consecutive terms on the Lincoln City Council from 1972 until 1988. (Courtesy of Pat Pike.)

Lincoln's first mayor, W.D. Henderson, was elected at the city's incorporation in 1911. He served until 1912 and then served as mayor again from 1919 to 1920. Mayors of Lincoln whose photos were unavailable for this grouping include Tom F. Griffin Sr., Walter M. Jones, Andy Allred, and Jack Hudson.

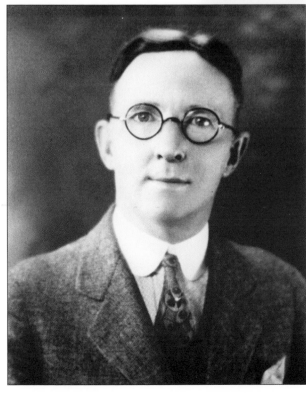

J.J. Gladden served as Lincoln mayor from 1914 to 1918.

W.A. Carpenter served as Lincoln mayor from 1920 to 1921.

Ruben F. Landham served three terms as Lincoln mayor: from 1921 to 1924, from 1926 to 1928, and from 1932 to 1933.

E.D. Acker served two terms as Lincoln mayor: from 1924 to 1926 and from 1928 to 1932.

J.J. Kirksey served as Lincoln mayor from 1933 to 1936. The Kirksey administration was responsible for implementing a water system for the city. It was built during President Franklin D. Roosevelt's WPA programs.

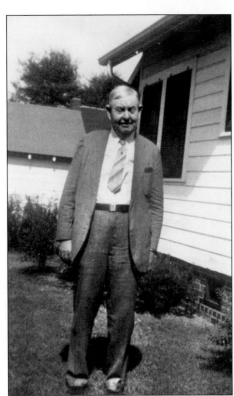

W.R. Tuck served as Lincoln mayor from 1936 to 1940.

Kennedy Watson was in his third term as mayor of Lincoln when illness forced him to resign. He served from 1958 to 1967.

William C. (Bill) Sullivan, elected mayor in 1952 at 25 years old, was the youngest mayor ever to take office in Alabama. Bill was born in 1926, and his family moved to the old home place on Magnolia Street in Lincoln just after he entered the first grade. His grandparents were W.B. and Eula Sawyer Montgomery, and his parents were Archie and Louise Montgomery Sullivan. Bill graduated from Talladega County High School in 1944, and because of World War II, Fred Hackney was the only other boy in the class. Bill joined the U.S. Navy in September 1944. After his tour of duty, he attended law school at the University of Alabama on the G.I. Bill and graduated in August 1949. He opened a law office in Leeds but also did legal work for the City of Lincoln. He was elected mayor of Lincoln in 1952 with no opposition. However, when he ran for re-election in 1956, he was opposed by a Baptist candidate. Bill won the election, and he often joked that although there were twice as many Baptists in Lincoln as there were Methodists, he won with a count of 138 to 41. Bill's first major purchase for the city was a $1,500 army surplus fire truck in 1957; interestingly, that truck saved Bill's home from a chimney fire in 1982. In the late 1950s, Bill was elected circuit judge for Talladega County and went on to become the longest-serving circuit judge in the state. Judge Sullivan, as he came to be known, was an avid sportsman and a beloved citizen. A charter member in the Historic Lincoln Preservation Foundation, he was instrumental in its formation. (Courtesy of the City of Lincoln.)

William "Bill" Roberts served as mayor pro-tem in 1967.

Raymond Martin served as Lincoln mayor from 1968 to 1972.

Sidney Fomby Jr. became Lincoln's first African-American mayor in January 1991. He served out the two remaining years of Lew Watson's fifth term in office. At the time of his election, Fomby was a first-term councilman from Ward 3. He pledged "to work with all citizens of Lincoln."

SAMPLE BALLOT
MUNICIPAL ELECTION
TOWN OF LINCOLN
AUGUST 8, 1972

INSTRUCTIONS

THE VOTER SHALL RECORD HIS CHOICE BY PLACING A CROSS-MARK (X) BEFORE THE NAME EXPRESSING HIS CHOICE.

MAYOR
(Vote For One)

268	[X]	Carroll L. Watson, Jr.
51	[]	J. O. Davie
90	[]	James T. Watson

COUNCILMAN — Place No. 1
(Vote For One)

275	[]	Milton R. Hamby
127	[]	Travis H. McCaig

COUNCILMAN — Place No. 2
(Vote For One)

96	[]	Thomas W. Hinton
46	[]	Doraneze L. Green
141	[]	J. W. Taylor
121	[]	Willie J. Wills

COUNCILMAN — Place No. 3
(Vote For One)

250	[]	David Jones
147	[]	Mrs. J. D. Hubbard

COUNCILMAN — Place No. 4
(Vote For One)

230	[]	Mary C. Henderson
80	[]	Thomas F. Disspain
95	[]	George G. Korreckt

COUNCILMAN — Place No. 5
(Vote For One)

259	[]	Ray Pettis
146	[]	Horace E. Glidewell, Jr.

The final ballot count from the 1972 municipal election is shown here.

Carroll L. Watson Jr. has served as the mayor of Lincoln for nearly 28 years. First elected in 1972, he was mayor until he resigned in 1991 to take a job in the private sector. He was then re-elected in 1996 and continues to be the city's top official today. During the Watson years, Lincoln has seen a major expansion of the water system, has had its corporate city limits extended, has seen the first wastewater treatment plant, and has recorded the largest population increase in the city's history. A new city hall has been built, city parks have been established (Moseley, Kirksey, England, and Britt), rural health care arrived, and the city received the first federal loan in the nation for a cable television system. Watson was instrumental in leading Honda Manufacturing of Alabama to locate on 1,500 acres of Lincoln property. "Honda brings opportunities for a generation of people to improve their standard of living. People can get better jobs with higher paying wages and kids don't have to go away to get a good job. Honda has brought statewide recognition to Lincoln. And perhaps most impressively, every Honda vehicle that leaves, carries a Made in Lincoln, Alabama sticker," he said. His parents were Carroll and Ruth Watson Sr.

Sadie Britt, whose parents were Moses and Izora Stevenson from Talladega, was the first African-American woman to serve on the Lincoln City Council. The widow of L.D. Britt, Sadie was appointed by Mayor Lew Watson in 1993 to fulfill the term of Ronald Wright. She won the 1996 election and then ran unopposed in 2000. She is currently in her third term as a councilwoman. Sadie is a retired educator with the Talladega County School System, where she worked for 30 years. She has one son, David C. Britt. (Courtesy of the Britt family.)

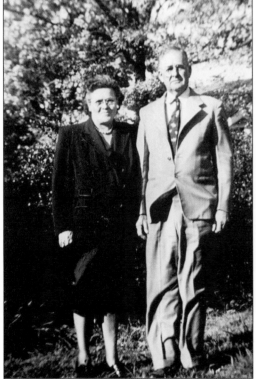

Bertha England, shown here with her husband J.L. England, was one of the first female members of the Lincoln City Council. Called an alderman at that time, Bertha, along with Mrs. Flora Landham and Mrs. Birdie H. Davis, were elected September 15, 1924. Mayor E.D. Acker and Aldermen A.J. Moseley and A.C. Wyatt joined the ladies. In the election, 54 females and 72 males were registered voters in the town of Lincoln. (Courtesy of the England family.)

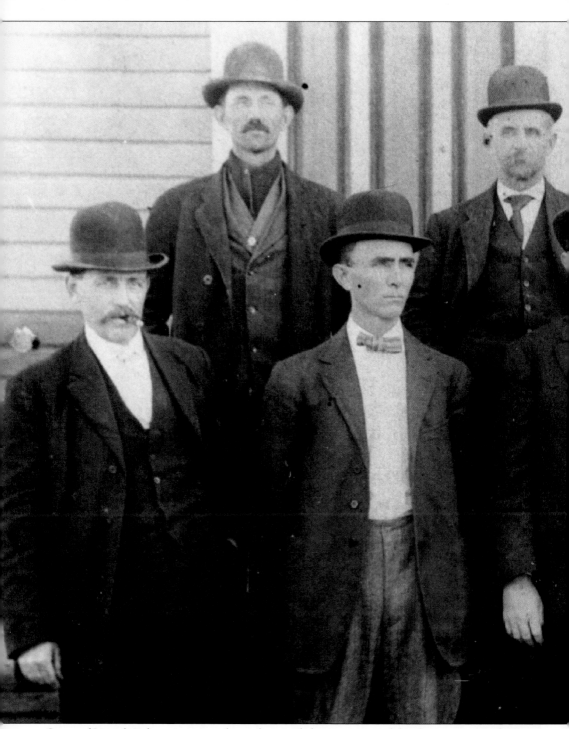

Some of Lincoln's first city council members and the mayor posed for this picture on the steps of the Lincoln Depot. Although the picture is undated, it is known that the first mayor and council were elected at the city's incorporation in 1911. Pictured from left to right are (front

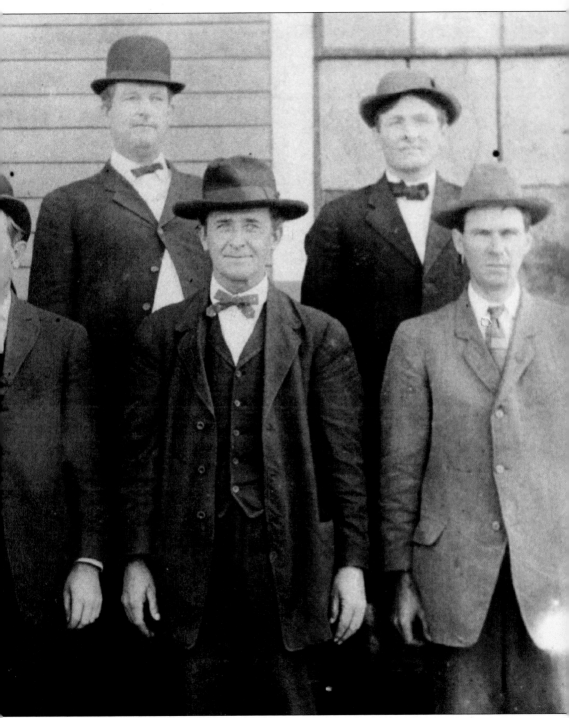

row) S.A. Burton, Councilman J.M. Cunningham, Councilman J.L. Richey, E.D. Acker, and Town Clerk W.C. Madden; (back row) Councilman W.M. Jones, R.B. Burns, Mayor W.D. Henderson, and L.U. Dickinson. (Courtesy of City of Lincoln.)

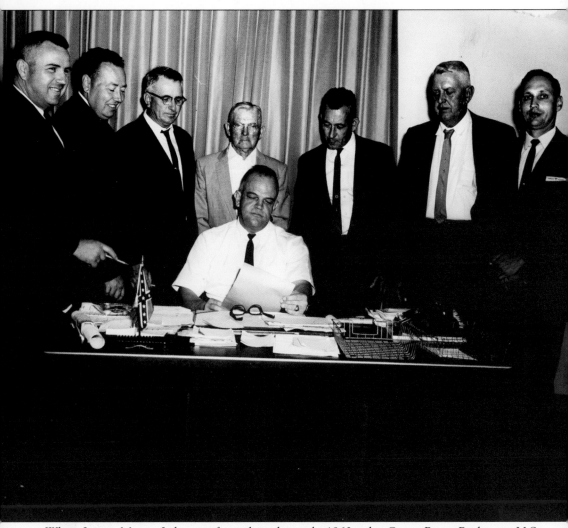

When Logan Martin Lake was formed in the early 1960s, the Coosa River Bridge on U.S. Highway 78 was slated for removal because it was too close to the water and boats could not safely pass underneath the structure. A group of local citizens went to the state and federal government and convinced officials to leave the bridge in place and raise it to a sufficient level. It spans the river today at its present level because of the efforts of these people who are, from left to right, the following: (standing) United States congressman Bill Nichols, unidentified, Travis McCaig, William Joseph Watson, Oscar Phillips Jr., Foster Smelley, and unidentified; (seated) A.W. Todd. The photo is dated April 1963. (Courtesy of Pat Pike.)

Six
A Place to Worship

"Surely the Lord is in this place…"
—Genesis 28:16

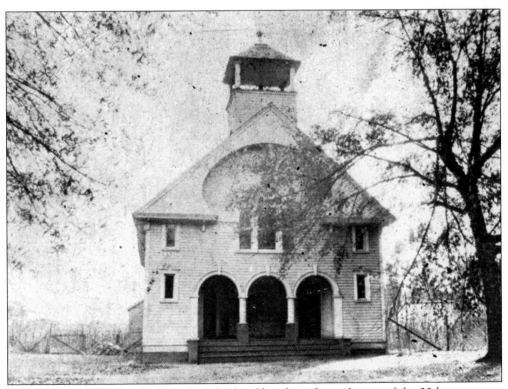

This is a picture of Lincoln United Methodist Church in the early part of the 20th century.

Lincoln United Methodist Church was moved from Patton's Chapel in 1886. T.J. Brewer, J.C. Wilson, and Bernhard Schmidt were instrumental in the move. Names on memorial windows indicate those named above and the Crawfords, Sawyers, Mrs. Angie Burns, Dickinsons, Watsons, Montgomerys, and Carpenters as early workers in the church. (From *The Daily Home*, April 29, 1972, by Mary L. Henderson)

Pine Grove Mission Baptist Church, organized in 1868 under the leadership of the Reverend Woods, is one of the original organizers of the Rushing Springs District Baptist Association. Pine Grove School, later called Charles R. Drew School, began as a church school in this Baptist church. Around 1903, the church devoted two acres and a one-room structure for grades one through six. Later, a frame structure with six rooms housing grades one through eight was built and began public schools for the area's African Americans. The name was later changed to Lincoln Junior High School. The church burned down in 1926 and was rebuilt the same year. A church building program was launched in 1964, and members moved into the new church in July 1966. In October 1984, plans were begun for an educational building. A ground-breaking ceremony was held on January 27, 1985. The $45,000 loan note was paid off and, on August 20, 1989, the note burning was held. (Courtesy of John David McClurkin.)

Refuge Baptist Church was constituted July 11, 1851, by Dearborn Acker and Jordan Williams. First located on Alligator Creek about eight miles northeast of the oldest part of Lincoln, it was later moved to its present location, about five miles north of the railroad tracks, where it still serves the community. At the church's original location was a large rock from which ladies mounted their horses. Mr. Bell, who sat on that rock during services, opposed moving to a new site because of the rock. He was pleased when Mr. O'Dell moved the rock to the new location. (Taken from the minutes of Refuge Baptist Church; courtesy of John David McClurkin.)

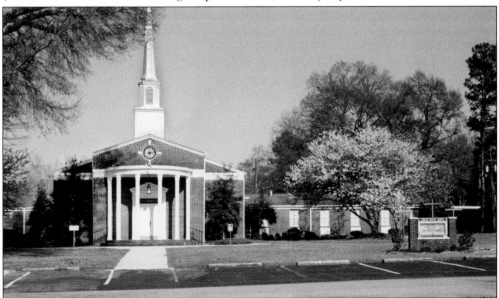

Lincoln Baptist Church was organized by the Coosa River Association on October 15, 1887, and charter membership was composed of 12 members from Blue Eye Baptist Church and 12 from Refuge Baptist Church. The first services were held in the school, located near Lincoln Cemetery, and the Rev. T.K. Trotter was the first pastor. The old church was established in 1887 on the same site as Lincoln's present Baptist church. It was torn down and replaced by the new church around 1956. Some of the earliest members were the Burns, Laws, Ackers, Burtons, Griffins, Trotters, Beavers, Mynatts, and Hackneys. (Courtesy of John David McClurkin.)

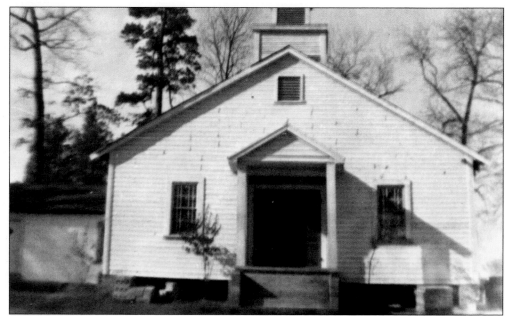

Blue Eye Baptist Church was constituted in 1834 by William McCain. The first building was made of logs with a large fireplace for heat. The church name came from the nearby creek, Blue Eye, named by the Native Americans. Behind the pulpit were rooms where slaves sat during services. This building was used as a schoolhouse during the week, with the grade school taught by Miss Fannie Bowie; J.C. Wilson was principal. Some of the families with children enrolled were Janes, Embry, Tuck, Wilson, Watson, Schmidt, and Bell. (Courtesy of Connie O'Dell.)

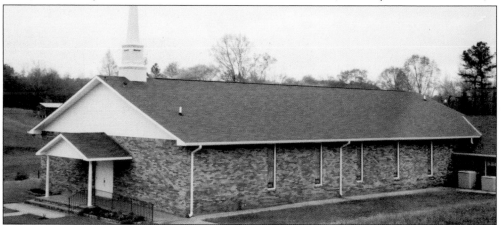

St. Mary's Missionary Baptist Church was organized in 1884, and a small group of Christians living in the eastern Lincoln community were the first worshippers. The first services were held in a log cabin by the railroad tracks. In the early 1900s, members purchased an acre of land from Mr. J.N. Hutto. St. Mary's and Pine Grove Baptist Church were among the churches that served as elementary schools for the community children. St. Mary's is believed to have been a school from its beginning until the late 1940s. The first pastor was the Rev. George Murray and the first deacon was Henry Pearson. St. Mary's served as the annual meeting place for the Lincoln Note Singers, reorganized in the 1960s. Under the direction of the 13th pastor, Rev. Lynnwood Westbrook, the Senior Choir became well known recorded their first songs, "The Resurrection" and "Make A Step." (Courtesy of John David McClurkin.)

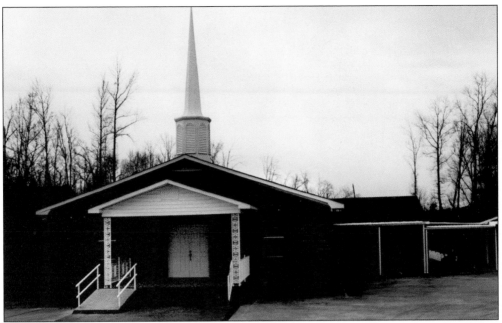

On June 26, 1943, a body of believers met at the home of Mr. and Mrs. George Dempsey to make plans for organizing Patton Chapel Baptist Church. The group met again on July 6, 1943, to finish plans for organizing the church. On July 18, 1943, this group met at Refuge Baptist Church to organize the Patton Chapel Missionary Baptist Church. Rev. Lester Doss was elected as pastor. On October 13, 1943, the church met for the first time in the new building. In 1981, the congregation decided again to re-build. The last service in the old building was held on July 4, 1982, and the first service in the new building was held on July 11, 1982. (Courtesy of John David McClurkin.)

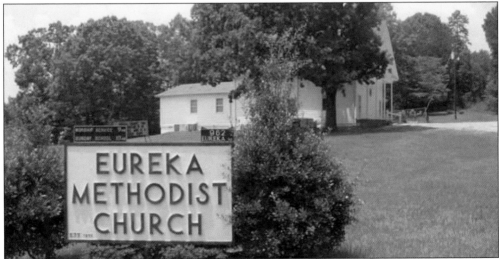

Eureka Methodist Church was founded in November 1891 when land was given for the church by Thomas A. Jones and his wife, Fannie. This deed is in the hands of the present church members. The building was constructed in 1892 and the church joined the North Alabama Conference in 1893. Joe Spencer was the first minister, and the service was opened with the song, "Oh Happy Day." (Courtesy of John David McClurkin.)

Lincoln Church of God was organized in 1959 by the Rev. J.R. Woodard. Land was purchased in 1963 and construction commenced in March 1964. The church was dedicated in June 1965, and the mortgage was burned in December 1971. (Courtesy of John David McClurkin.)

Dry Valley Baptist Church was constituted in 1886 after being organized as a church in 1880. Charter members were Mr. and Mrs. George Clements, Ella Hollingsworth, Ida Lula Hollingsworth, J.C. Hollingsworth, and Mr. and Mrs. John McCain. In 1958, the existing sanctuary was built using the recommended plans of the Alabama Baptist Sunday School Board. For $1, Will Bentley sold to the church the land on which the pastorium is located. The educational building was erected under his leadership. On July 25, 1982, this building was dedicated in his honor. (Taken from *Coosa River Baptist Association Alabama 1833–1983*; courtesy of John David McClurkin.)

Seven

YESTERDAY
AND TODAY

*"New life came to the town as a result of the work…now there are six square miles of
incorporation… Lincoln is looking up."*
—Mary C. Henderson
Talladega Daily Home, c. 1976

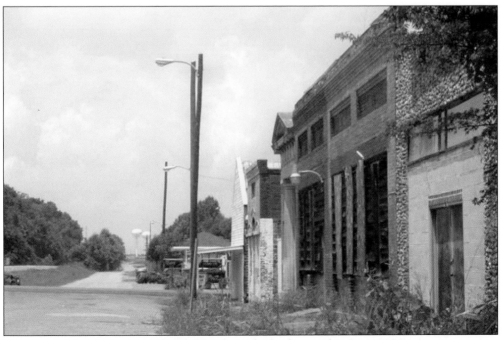
Downtown Lincoln is pictured with Honda in the background in June 2004.

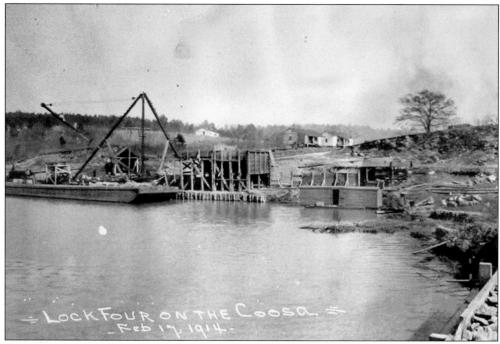

These two photographs and the one on the following page are actually one panoramic view of Lock Four on the Coosa River. Taken February 17, 1914, the view is from the St. Clair County shore. Note the large building on the hill in the background. In 1880, this was the Southeastern United States Headquarters of the Army Corps of Engineers. The locks, built in a series along the river, make the waterway navigable. A boat traveling either up or down the river would sail in a lock and water would let in or out, raising or lowering the boat and allowing it to continue on its path. (Courtesy of Bob Watson.)

Today, all evidence of Lock Four is under water except for the concrete wall and the building that housed the workers (shown behind the trees). On calm days, a change in the current can be seen at the site of the underwater lock. The lock became obsolete with the building of Logan Martin Lake in the early 1960s. (Courtesy of Bob Watson.)

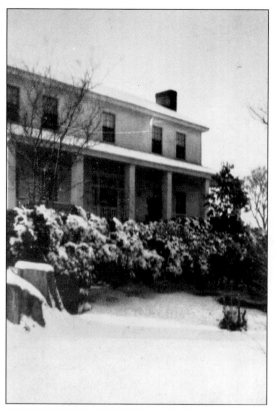

The Watson House, pictured *c.* 1935 and today, is one of the few Greek-Revival, I-style homes left in Alabama. The house is believed to have been built *c.* 1853 by Warren Truss Jr. Thomas J. Watson purchased the home and surrounding acreage in 1919, and it remained in the Watson family for 80 years. The house escaped destruction in 2000 when the construction of Honda Manufacturing of Alabama began, and it was eventually donated to the Alabama Historical Commission. It is now owned by the Historic Lincoln Preservation Foundation and is the site of civic and social events in the city. (Courtesy of Bob Watson.)

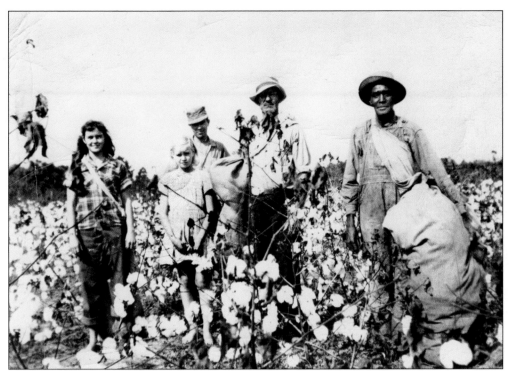

In the 1940s, the Parkers were one of many families who farmed cotton fields in the Lincoln area. Jane, Joyce, Billie, and Pitt Parker, along with Henry Redden, took time out in late summer of 1948 to pose for this photograph, taken where the Talladega International Speedway sits today. The speedway, pictured below in 2004, draws to Lincoln more than 100,000 NASCAR fans twice a year. (Courtesy of Joyce Varnes.)

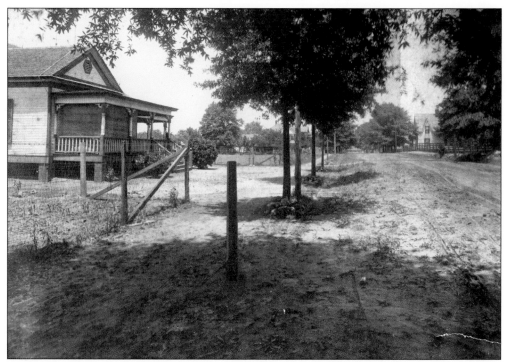

Magnolia Street, shown today (below) and in this undated photograph (above), has been a major thoroughfare in Lincoln since the late 1800s. This view is facing east toward the railroad tracks near Third Avenue. Note the House of Seven Gables on the right and the Oaks near the center on the left side of the road. (Courtesy of Harold Caudle.)

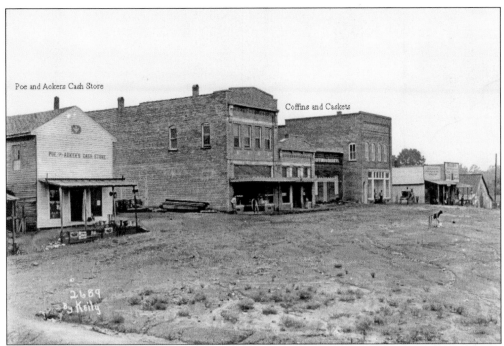

Today, James Avenue business is limited to an antique refinishing store located at the far end, near Magnolia Street. However, in the photograph above from the collection of John David McClurkin, several active businesses thrive. Taken c. 1925, the image shows Poe and Ackers Cash store in the foreground, next to the T.J. Watson Mercantile store, a bank, and a coffin and casket supply house. Note the horse and buggy in front of the two-story building. (Courtesy of John David McClurkin.)

In 2000, Honda Manufacturing of Alabama turned hay fields and hunting grounds into a multi-million dollar assembly plant that employs thousands of people from Lincoln and the surrounding area. After years of negotiations, the Watson family, who sold a large amount of acreage to the company, announced Honda in their own, unique way: with bales of round hay that spelled Honda.